CONTENTS

ACKNOWLEDGMENTS

This project began with the help of Ulrike Smith of the Brazos Heritage Society and was implemented with the enthusiastic support of Nan Ross at the Carnegie History Center in Bryan, Texas. My sincere thanks are extended to both of these women who got this project rolling and provided access to so much of the material included in this book. Many others lent a much-appreciated hand:

Billie Dopslauf went through countless microfilmed newspaper articles searching for information that added richness to the annotation. She was especially helpful in locating materials for the chapter on lifestyles and leisure.

Bill Page, local historian extraordinaire, directed me to the archives of the Carnegie History Center as the starting point for this project. He also made suggestions about the type of photographs to include—focusing on compelling images rather than trying to make this into a photographic history of the city.

Liz Zemanek provided information on the local Czech community, businesses on the north end of Main Street, and St. Joseph Parish. She also introduced me to Lee Fazzino, who shared stories about a lifetime of cotton farming from Stone City to Mumford around Mudville in northwestern Brazos County. Mr. Fazzino took me on a tour of the Brazos Bottom, and both he and Liz helped identify images from the Carnegie History Center's collection of photographs.

My neighbors Neal Jones, his brother Jimmy Jones and Jimmy's wife Jan Houdek Jones all contributed stories and newspaper articles about Bryan. All three are native Bryan residents and were eager to tell their stories about growing up in Bryan. The Jones family has roots in western Brazos County that go back to John H. Jones's settlement on the Brazos River, near the present site of Jones Bridge, as early as 1829. I am grateful to Neal Jones for reading the entire manuscript and suggesting several revisions.

Regina Opersteny shared stories about settlement on the west side of Brazos County. Bill Terrell was helpful with information about the southern part of the county around Allenfarm and tried to help me identify the location of some of the Brazos River flooding photographs. Theresa Ruffino Connaughton provided information about the Italian community.

Houston McGaugh, director of the Star of the Republic Museum, provided access to the map of Texas railroads shown on the frontispiece. It was published by the Calvert Realty Company and is from the museum's collection. The museum is located at Washington-on-the-Brazos State Historic Site in Washington, Texas.

Sgt. Jason James and Officer Alice Anderson of the Bryan Police Department were eager to provide photographs from the police department's archives. They also supported including in this volume an acknowledgment of the sacrifice of Levi Neal, a Bryan policeman who was one of Texas's first African American peace officers to die in the line of duty.

Katherine Weimer of Texas A&M University's Evans Library Map Room provided scanned maps from different eras in Bryan's history. Their map showing the orientation of streets in Bryan's Central Business District is included in the first chapter of this book.

I want to end with a huge tip of the hat to Bryan's Carnegie History Center. Under the direction of Nan Ross, the staff of the Carnegie History Center was extremely helpful. Diane Peterson Smith contributed pictures from her Kemp High School yearbook. David Ely scanned hundreds of images to exacting specifications. Lou Vonne Johnson and Anne Preston located Carnegie resources and helped with editing the manuscript. Nan Ross read the entire manuscript several times and answered many of the editors' questions. Her knowledge of the library's archives is second to none, and her determined support facilitated bringing this project to completion.

Without all of these fine folks, this book would not have happened. It is a thrill to contribute a book about my adopted hometown to Arcadia Publishing's extensive collection that preserves snapshots of distinctive cultural landscapes from across the United States.

Unless otherwise noted, all images are from the Carnegie History Center in Bryan, Texas.

INTRODUCTION

In the late 19th century, Bryan developed as a market town serving the cotton-producing region along the Brazos River in East Central Texas. Today Bryan thrives not only because it is the center of a regional agricultural economy, but also because it is closely located to Texas A&M University and has responsibilities as the seat of government for Brazos County. Bryan is situated in the heart of the Texas Urban Triangle, with Dallas and Fort Worth to the north, Houston to the southeast, and San Antonio to the southwest.

In spite of being the county seat, Bryan did not develop around a courthouse square, as so many other Texas towns have. Instead, Bryan developed along its railroad, a few blocks west of its government offices. From the time of its founding, the heart of Bryan's central business district was Main Street, which is the focus of the first chapter. Bryan was a market town, and as such, its major businesses were banks, grocers, merchants, and cotton-related enterprises. In its early days, saloons flourished.

Almost immediately, the town's first settlers worked to make Bryan a better place. Coming from the American South, as well as such distant places as Sicily and Czechoslovakia, folks were drawn by land and opportunity. Bryan's new residents established churches, schools, fraternal organizations, and all kinds of civic clubs—each with ideas about how to enhance the quality of life in their new hometown. The Chamber of Commerce put out brochures touting Bryan as "A School Town" and "A City of Churches." These organizations are the focus of the second chapter. The third chapter contains snapshots depicting lifestyles and leisure activities. Just a handful of people who have called Bryan home are identified in the fourth chapter. Some names are well recognized locally because they adorn schools and thoroughfares, while other names have been lost over time.

Bryan exists because of its connections to other places. Today it is possible that its most important connection is to Texas A&M University in College Station. As one of the largest universities in the nation, A&M is by far the largest employer in the region and attracts more than 45,000 students from Texas and across the world to Brazos County each year. Football weekends in the fall and Bush Presidential Library events throughout the year attract large numbers of visitors as well. The importance of Aggieland to Bryan's present-day economy cannot be overstated; however, during Bryan's formative years, it was connections to cotton and the railroad that mattered most. In chapter five, the images illustrate connections to both A&M and to the cotton industry. A few examples of other local communities are included. Although Dallas, Houston, and San Antonio and the state government in Austin are vital, those connections to Bryan are simply not illustrated in this volume.

Finally, because of cotton's importance to Bryan's early history, the last chapter is about flooding along the Brazos River, where cotton was king. As cotton cultivation in the Brazos Valley grew, the economic ravages and personal sorrow caused by flooding also increased. By the early 1900s, enormous efforts were put into flood control, mostly to no avail. The images offered in this final chapter provide a glimpse into the devastation caused by the river's widespread flooding, especially in 1913, 1921, and 1926. Since the 1940s, dams upstream on the Brazos River and its tributaries have lessened frequent flooding at the scale shown in chapter six.

All of these photographs are from the Carnegie History Center's collection, and most have never been published. As one who is interested in both Texas water resources and local history, I am excited to include these unusual images in this volume.

The institutions, people, and connections in these photographs provide only a sampling of Bryan's history. I chose images that I thought were either representative or compelling, but there are still large gaps in the photographic record of Bryan waiting to be filled.

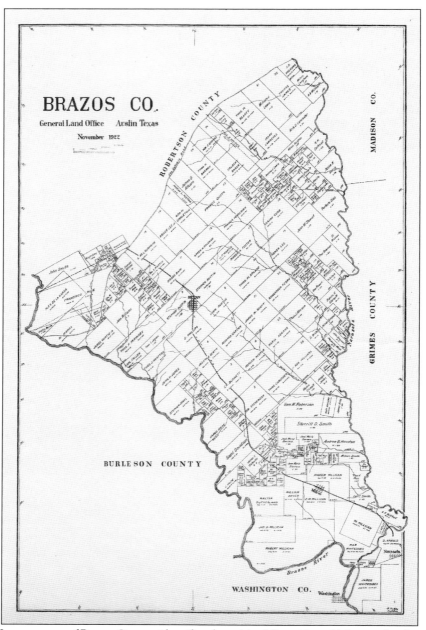

This 1922 survey map of Brazos County identifies the original Spanish and Mexican land grants and surveys awarded during the Republic of Texas period from 1836 to 1845. Bryan is the county seat and is located on high ground near the center of the county. The western boundary of the triangular-shaped county is the Brazos River. The eastern boundary is the Navasota River that flows into the Brazos at the southern tip of the county. Much of the northern boundary is the Old San Antonio Road, also known as El Camino Real. The railroad came to Bryan from the southeast and followed the high ground between the two rivers. This map is from *Maps of All Texas Counties* published in 1922 by Wolf and Bennett, care of American Royalty Petroleum Company of Tulsa, Oklahoma, and is available in the archives of the Carnegie History Center in Bryan, Texas.

One

MAIN STREET

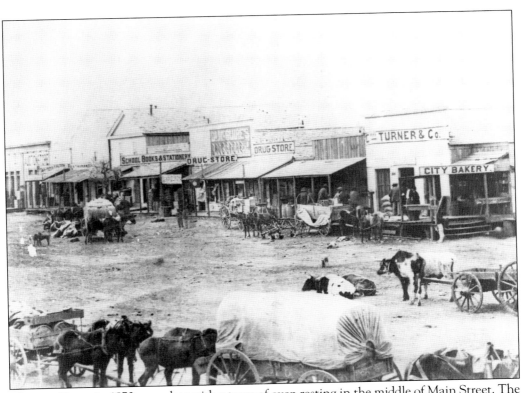

This was Bryan in 1870, complete with a team of oxen resting in the middle of Main Street. The numerous mule-, horse-, and oxen-drawn wagons were an indication that Bryan had already established itself as the market town for this part of the Brazos Valley. In 1885, the mayor and city aldermen passed, vetoed, and passed again an ordinance prohibiting loose livestock on Main Street.

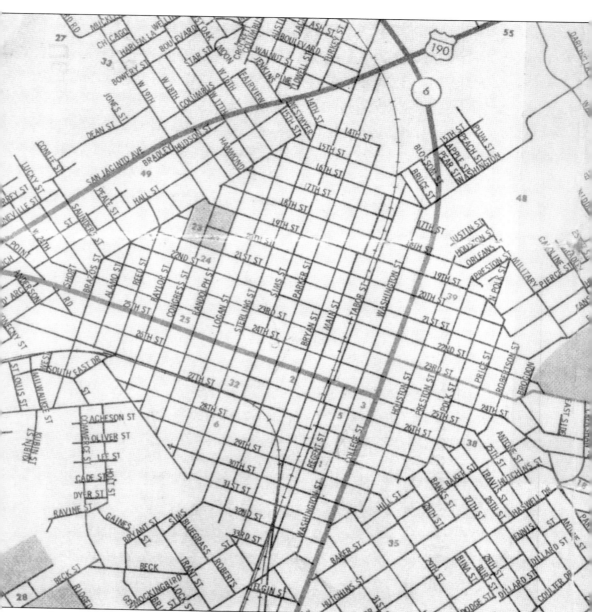

Approximately 50 years ago, a map of downtown Bryan looked much like it does today, with its east-to-west streets being consecutively numbered. Two notable changes have occurred since then: Nineteenth Street is now Martin Luther King Boulevard, and Twenty-fifth Street is William J. Bryan Parkway. This map is slightly skewed, as the main rail line runs almost due north. (Courtesy of Map and GIS Collections at Texas A&M University Libraries.)

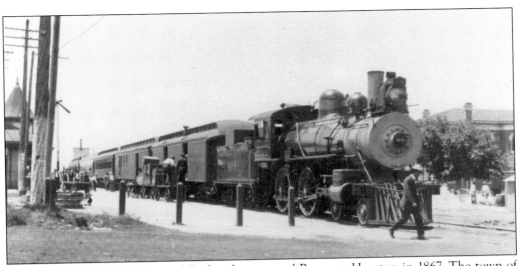

The Houston and Texas Central Railroad connected Bryan to Houston in 1867. The town of Millican, 20 miles south of Bryan, was the terminus of the railroad from 1860 to 1867, as construction of the railroad from Houston halted during the Civil War. With the arrival of the railroad and an election that moved the county seat to Bryan from nearby Boonville, Bryan's position as the market town for this part of the Brazos Valley was set. Both passenger and freight service went through Bryan. This photograph was taken in 1907 in front of one of the passenger depots. The back of the Carnegie Library can be seen across the tracks.

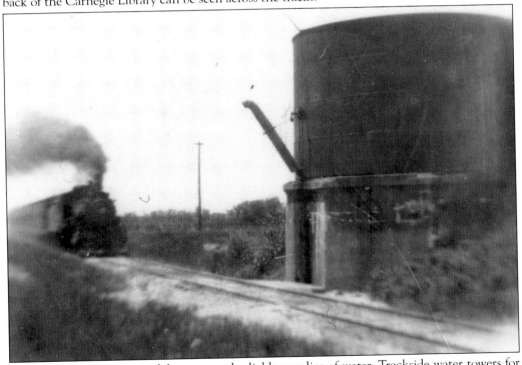

Steam locomotives required frequent and reliable supplies of water. Trackside water towers for refilling the locomotive's tender were located approximately every 15 miles along the rail line. This tower was in the open countryside south of Bryan.

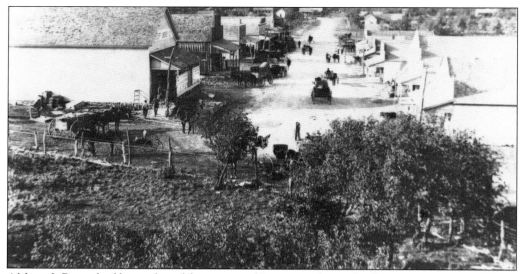

Although Bryan had been platted for an area of 1 square mile, its development encompassed only a fraction of its city limits during its early years. This photograph was taken looking to the south from what is now the location of the Bryan Ice House, where North Main Street ends at Martin Luther King Boulevard, previously known as both Nineteenth Street and Jackson Street.

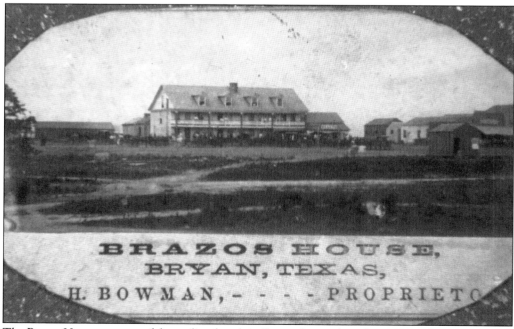

The Brazos House was one of the earliest hotels in Bryan. Located on the train tracks, its proprietor was W. H. Bowman. Advertisements in Galveston newspapers from the late 1860s tout its attached livery stable. It is not found on Bryan's Sanborn Insurance map of 1877.

IMAGES

of America

BRYAN

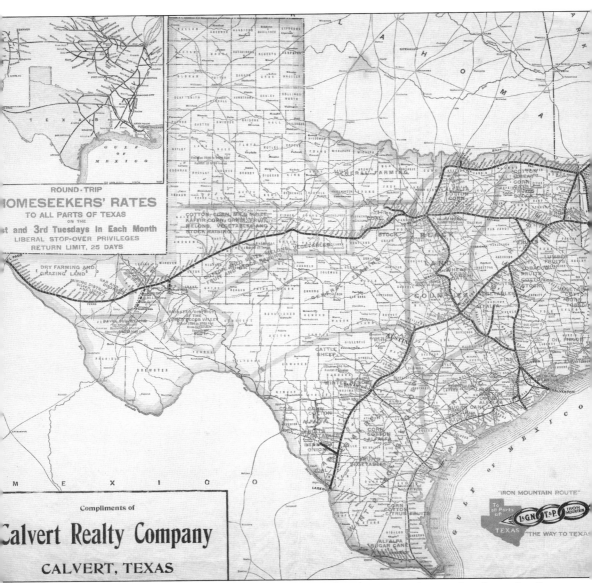

ROUND-TRIP
HOMESEEKERS' RATES
TO ALL PARTS OF TEXAS
ON THE
1st and 3rd Tuesdays in Each Month
LIBERAL STOP-OVER PRIVILEGES
RETURN LIMIT, 25 DAYS

Compliments of

Calvert Realty Company

CALVERT, TEXAS

The International and Great Northern (I&GN) Railroad was one of two railroads serving Bryan at the start of the 20th century. This 1909 map highlights the I&GN's lines through the state of Texas. Bryan is one county south of where the railroad's two major lines intersected at Hearne in East Central Texas. (Courtesy of the Star of the Republic Museum.)

ON THE COVER: Main Street was a busy place, especially on Saturdays, as people converged Bryan. In 1910, many mule-drawn wagons and at least one automobile clogged Bryan's wide still unpaved, downtown streets. This photograph was taken at the corner of Main and Tv sixth Streets by Carter's Studio and is on display at Bryan's Carnegie History Center. (C of the Carnegie History Center.)

IMAGES
of America

BRYAN

Wendy W. Patzewitsch

ARCADIA
PUBLISHING

Published by Arcadia Publishing
Charleston, South Carolina

Printed in the United States of America

Library of Congress Control Number: 2010934348

For all general information, please contact Arcadia Publishing:
Telephone 843-853-2070
Fax 843-853-0044
E-mail sales@arcadiapublishing.com
For customer service and orders:
Toll-Free 1-888-313-2665

Visit us on the Internet at www.arcadiapublishing.com

*This book is dedicated to local historians and regional geographers
everywhere whose passion for uncovering clues from the
past in order to interpret the richness of the present preserves
knowledge for future generations. Pause . . . and reflect.*

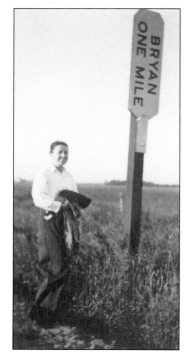

Slow down! You are about to enter Images of America: *Bryan*. This is the southern approach to Bryan taken from the railroad tracks east of Finfeather Lake in November 1936. Ora Mae Echols is posing by the milepost. (Courtesy of the Carnegie History Center.)

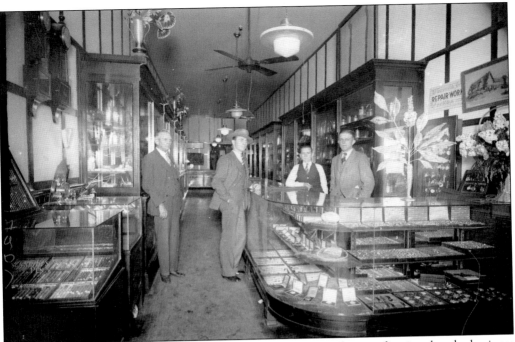

Caldwell Jewelers catered to an upscale clientele. In addition to being a fine jeweler, the business also fitted eyeglasses. A robbery that took place here in 1933 is part of Bryan's lore.

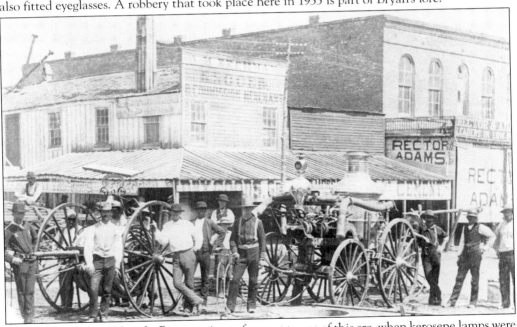

Fire was a serious problem for Bryan, as it was for most towns of this era, when kerosene lamps were used for lighting and fireplaces supplied fuel for heat and cooking. These firefighters were using a steam engine to pump water from one of five cisterns buried under the middle of Main Street. The first of several volunteer fire companies was formed by 1871, with the city providing the equipment. This photograph was taken at the corner of Main and Twenty-sixth Streets in 1887.

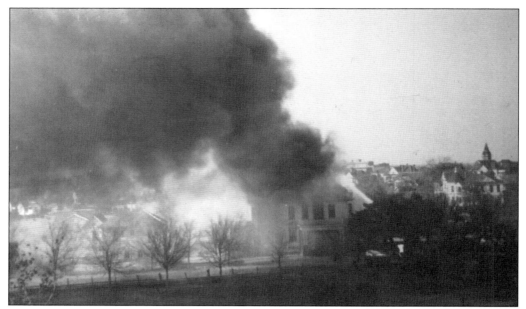

The home of H. O. Boatwright, president of the First National Bank of Bryan, was one of many homes and businesses to go up in smoke during Bryan's early history. In 1913, the City of Bryan purchased its first fire truck and, by 1921, hired its first full-time firefighter.

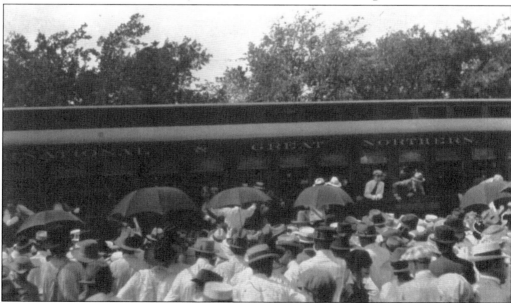

The International and Great Northern Railroad reached Bryan to much fanfare on August 30, 1900. The local newspaper headline called it "Bryan's Day of Jubilation." An estimated 5,000 to 6,000 people gathered to watch the first train arrive with 11 coaches and 500 passengers. After a speech from Texas congressman Thomas H. Ball of Huntsville, the crowd was treated to 10,000 pounds of barbecued beef, pork, mutton, and kid; 3,000 loaves of bread; 150 pounds of coffee; and "baskets of good things galore put up by the ladies of Bryan." The remainder of the celebration included baseball, fireworks, and an elaborate ball that evening.

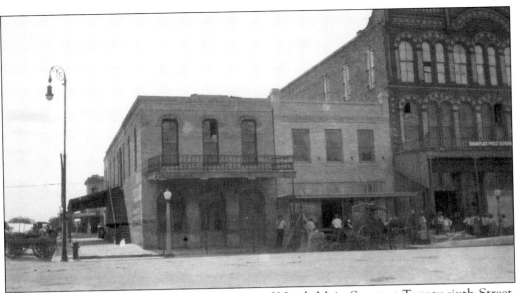

Rohde Saloon occupied the southwest corner of North Main Street at Twenty-sixth Street. During Bryan's early history, saloons were so common that A&M College cadets were discouraged from coming to Bryan. This saloon was demolished to make way for the Astin Building. The second floor of the building on the right was the law office of one of the Astins. None of these buildings remain.

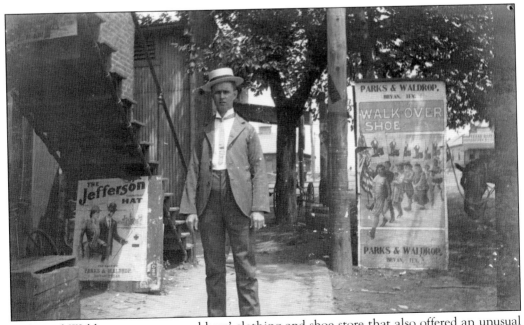

Parks and Waldrop was a men and boys' clothing and shoe store that also offered an unusual selection of shoes for problem feet, as advertised here behind A. M. Waldrop. It was also the place to go for Boy Scout uniforms.

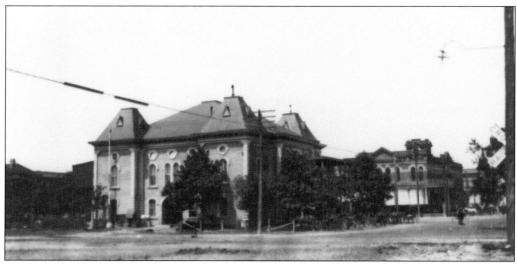

The opera house was one of the first public buildings in the city. In this 1900 image, its location was between the railroad tracks and Main Street. It was used for performances and civic meetings, including *Camille* and *Queena* in 1895. The north side of the first floor served as the city hall and fire station. The opera house was in the center section, with its stage to the south. A fire bell was located a few feet to the south of the building. This building was destroyed by fire in February 1909.

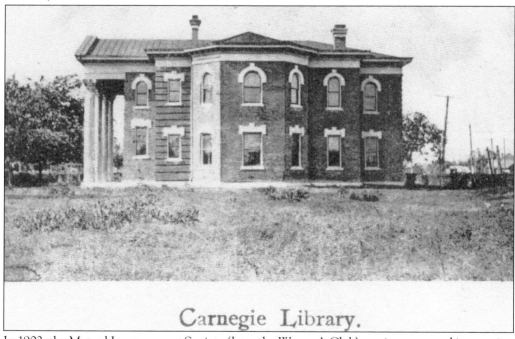

Carnegie Library.

In 1902, the Mutual Improvement Society (later the Woman's Club) was instrumental in securing a grant of $10,000 from the Andrew Carnegie Foundation for the construction of the city's first public library. The city donated the property at 111 South Main Street. In 1903, the building was dedicated. This unusual view of the south side of the library was taken shortly after the building was constructed. Buildings along Main Street today obscure this view.

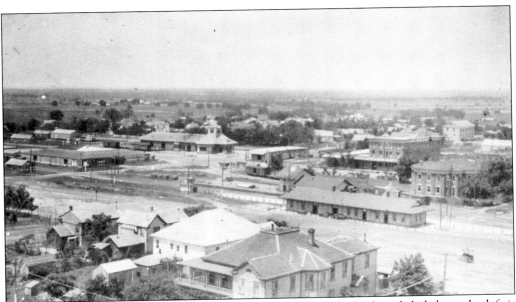

This c. 1905 image shows three Bryan train depots: Toward the back and slightly to the left is the International and Great Northern Railroad passenger depot, widely referred to as the I&GN depot. Near the front of the image and to the right is the Houston and Texas Central passenger depot, commonly referred to as the H&TC depot. The freight depot is across the tracks from the H&TC depot but was more of a platform.

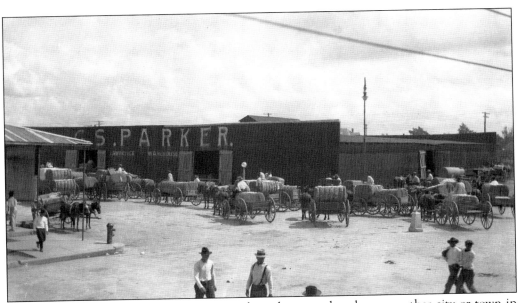

In 1906, Bryan boasted more wagon cotton brought to market than any other city or town in the world. The Parker Cotton Gin and Warehouse was located on the east side of North Main Street and received much of this cotton.

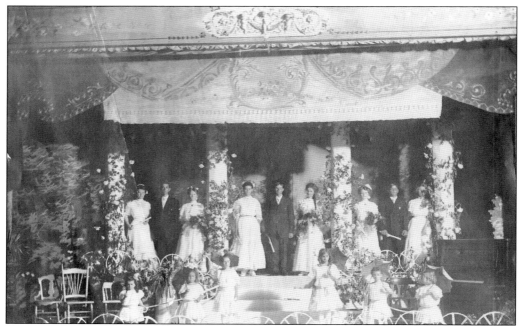

The ornate stage of the opera house was the site of the 1908 graduation ceremony for Bryan High School. The nine graduates were twins Edith and Ethel Cavitt, Stella Stuart, Hattie Searcy, Lucy Christian, Pauline Webb, John Newton, Willie Tucker, and Ed Vesmirovsky. Wesa Weddington, a descendant of Brazos County founder Harvey Mitchell, organized graduation ceremonies. The respected Wesa Weddington served Bryan schools until her retirement in 1946, including a stint as interim superintendent in 1937.

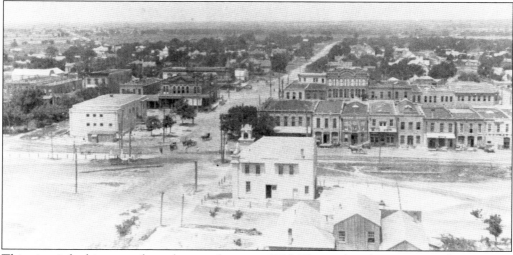

This view is looking west from the courthouse in 1909. The road to the west, near the center, is Anderson Street (now Twenty-sixth Street). To the right is North Main Street, and to the left of Anderson Street is South Main Street. The building that housed the old opera house and city hall burned in February 1909, and the new Palace Theater, which is the large light-colored brick building, had just been built near the corner of South Main Street. To its left, the cornerstone would be laid for the new Masonic Hall in the summer of 1910.

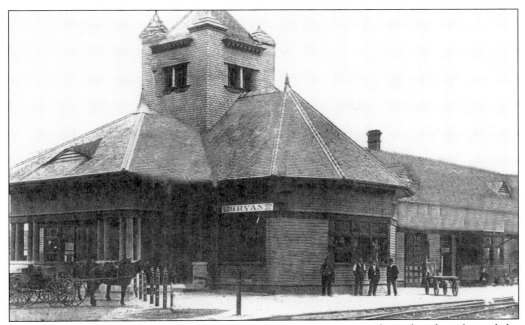

A platform used as a freight and cotton depot was located between the railroad tracks and the 100 block of South Main Street. To the north, a passenger depot was added across the tracks on the east side, adjacent to what is today the Clara B. Mounce Public Library. This was the International and Great Northern Railroad passenger depot in 1909.

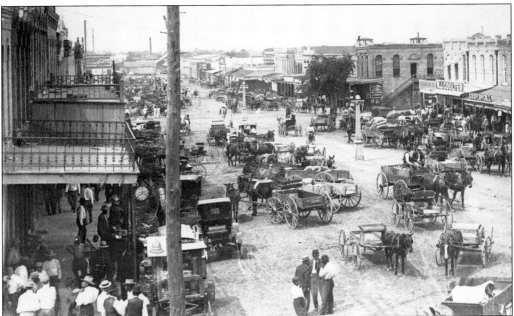

By 1910, most of the buildings in downtown Bryan were of brick construction, and Main Street itself was wide enough that large wagon teams could turn around. Streetlights adorned the center of Main Street, and the smokestack of a cotton gin is visible at the north end of town. On the utility pole in the foreground is a sign indicating that Bell Telephone service was available nearby.

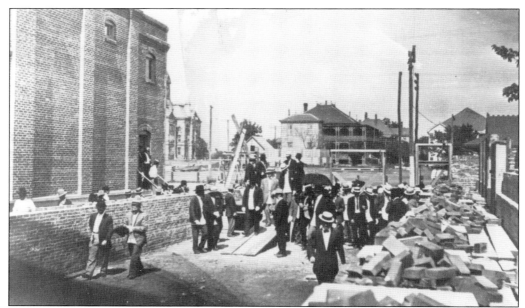

The cornerstone ceremony for the construction of the Masonic Hall, designed by architects Flanders and Flanders of Dallas, was held at 107 South Main Street on June 15, 1910. The Masons were an influential organization in early Bryan. Henry Bates Stoddard was Grand Master of the Knights Templar Organization, the highest national office, from 1901 to 1904. It was unusual for someone from such a small town to hold this high office.

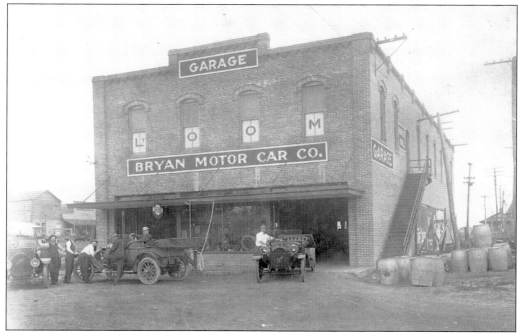

The Bryan Motor Company was owned by Fred Cavitt and located on East Twenty-fifth Street. It shared this building with the Loyal Order of the Moose Lodge (LOOM). There is a Michelin sign hanging from the front of the building. To the left, in the background, is a storefront advertising hides and pelts.

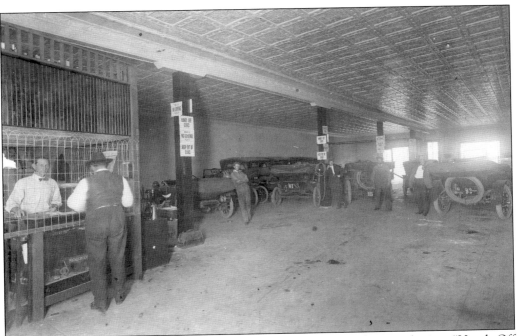

Through the open door of the Bryan Motor Company were posted signs advising, "Hands Off Cars," "This Is a No Loafing Place," and "Keep Out of Cars." The license plates had two digits and were followed by the word "Bryan."

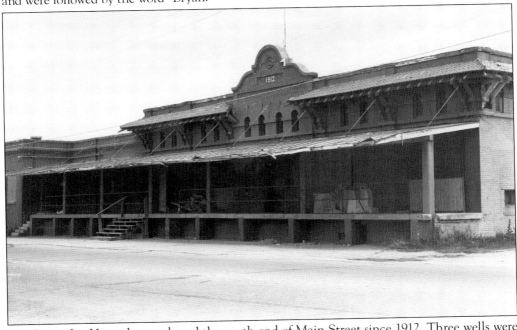

The Bryan Ice House has anchored the north end of Main Street since 1912. Three wells were drilled to a depth of 265 feet for water supply, and two cement reservoirs provided for additional storage. When the city moved the waterworks even farther north, the wells on this site were used for making ice. As of this writing, the north end of Main Street is undergoing renovation.

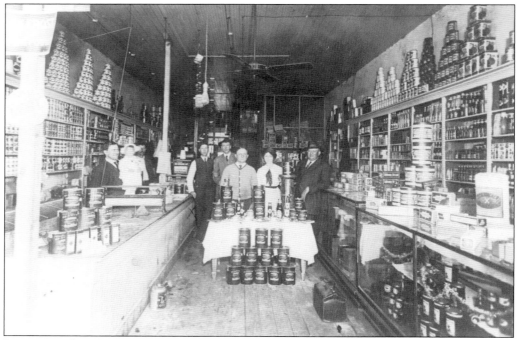

Jesse Hensarling (far right) was in the grocery business in Bryan for decades. The interior of his retail business is pictured here in 1912.

The Howell family had a wholesale grocery business on the west side of the tracks and a lumberyard on the east side of the tracks. This 1913 image shows the interior of their grocery. The three-story Howell Building has long anchored the west side of the 100 block of South Main Street, and it was from the upper floor of this building that many parades were photographed.

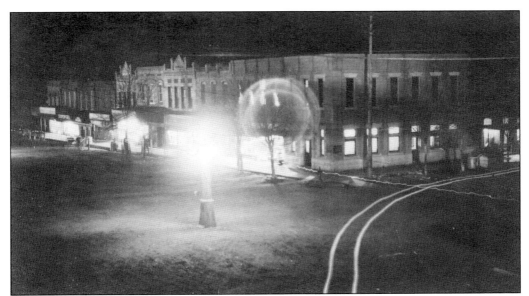

Streetlights were located in the middle of Main Street until 1915. The successful operation of the streetlights was a constant problem and was often referred to in the minutes of the city council. When the city took over the operation of the Light and Water Company in 1909, it was not to furnish electricity to consumers, but rather to do a better job of keeping the streetlights functioning.

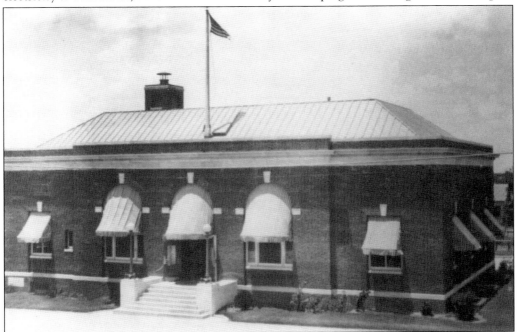

This is the Federal Building at the corner of Parker and Twenty-sixth Streets. Bryan's first post office transferred from Boonville in 1866. Inadequate facilities and fire forced its relocation at least five times. In 1915, the post office moved to this Federal Building, and with it came free city mail delivery. John E. Astin was postmaster from February 15, 1915, to January 30, 1917. The building remains in use by various government offices, although it no longer serves as the post office.

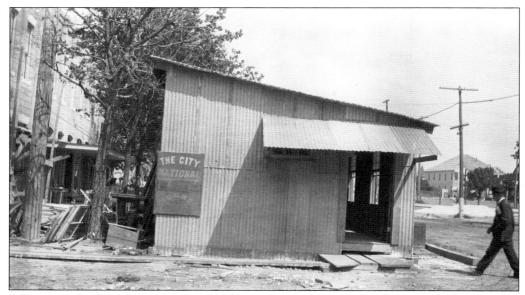

Advertising for the new City National Bank appeared all over town. This is in an alley near the main rail line.

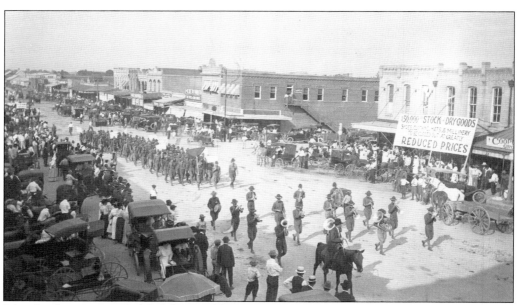

John Conlee, city marshal, led this World War I–era parade on horseback. Marching down Main Street behind him are members of the A&M College band, followed by members of the Corps of Cadets. Main Street had just been paved in 1915 using mules, ploughs, and a steamroller. New tall and slender streetlights were installed on corners, replacing shorter lights located in the middle of Main Street.

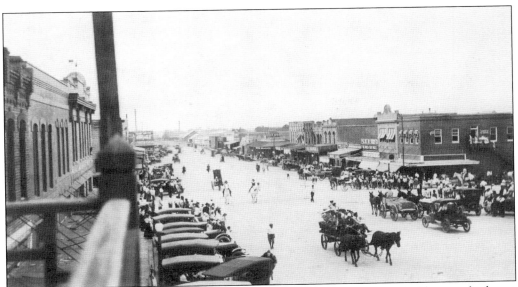

This parade, moving south down Main Street during the same era, was led by a mule-drawn wagon carrying a band. The fourth building from the corner, located across the street, was the Magnolia Saloon. Its proprietor, C. Vesmirovsky, advertised that women and children were not admitted. At the north end of the street was the Parker Gin.

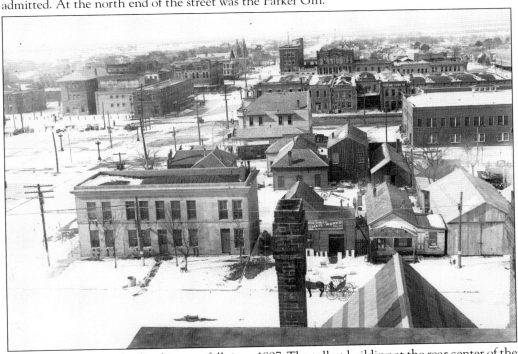

This 1918 storm was the first big snowfall since 1897. The tallest building at the rear center of the image is the Astin Building, and to its right is the Parker-Astin Building. To the left is the tower of St. Andrews Episcopal Church. At the left edge of the photograph is the Carnegie Library, now the Carnegie History Center, and to its right is the Masonic Hall. All of the aforementioned buildings, with the exception of the Parker-Astin Building and the courthouse, are still present.

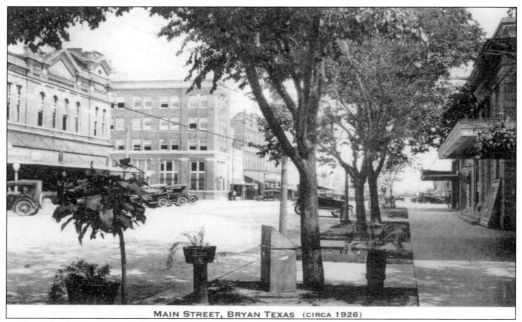

MAIN STREET, BRYAN TEXAS (CIRCA 1926)

Although the cars are different, this 1926 postcard image of Main Street is remarkably similar to what Main Street looks like today after its recent revitalization. (Courtesy of the Downtown Bryan Association.)

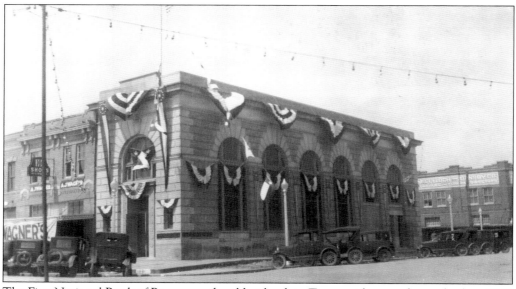

The First National Bank of Bryan was the oldest bank in Texas, with roots that go back to 1867. It was also the first bank in the United States to offer night depository service. The bank operated from this location at 108 North Main Street for more than 100 years. This particular building was constructed in 1919. Members of the Bryan family, after whom the city is named, served for generations in the management of this community-based bank.

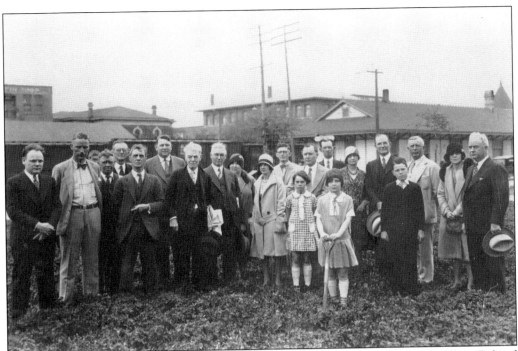

In 1929, a ground-breaking ceremony was held for a new city hall and municipal building. Behind the crowd is one of the passenger depots, the Masonic Lodge, the Carnegie Library, and the Howell Building.

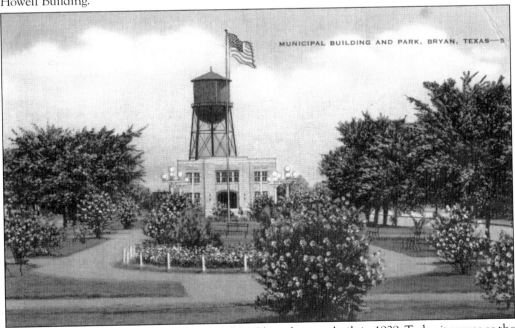

This is a postcard image of the new city hall building that was built in 1929. Today it serves as the Children's Museum. Behind it is the city water tower, which is no longer there. In the foreground is the city park, now the site of Bryan's Clara B. Mounce Public Library.

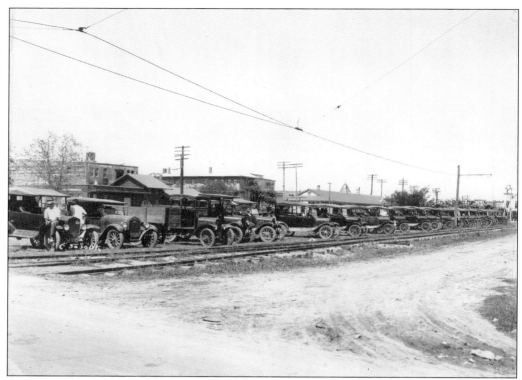

M. Bonneville owned the first automobile in Bryan in 1901. These automobiles and one early truck were lined up along the tracks in front of one of the passenger depots. In the background are Myers Hardware and the Carnegie Library, both of which front Main Street. C. Sosolik, a professional photographer in Bryan, captured this image. Sosolik is buried in Bryan's Mount Calvary Cemetery.

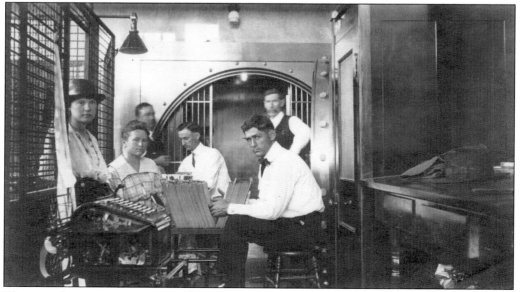

These employees were transacting business in the vault of one of the Main Street banks.

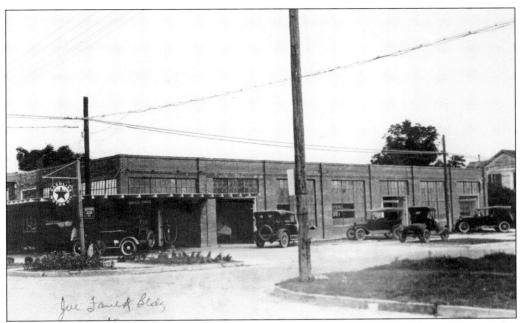

The Joe Faulk Building and one of Bryan's first gas stations are pictured around 1921. Prior to this time, gasoline was purchased in five-gallon cans from a wholesale distributor.

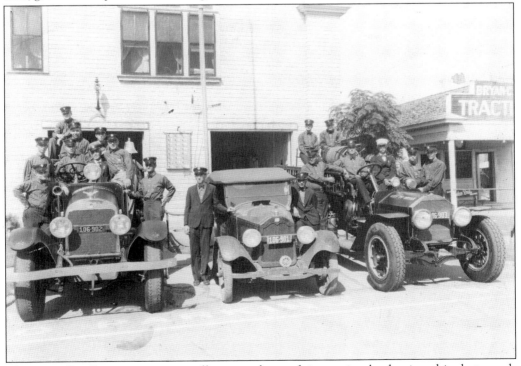

The Bryan Fire Department was a well-respected part of city services by the time this photograph was taken in 1928. Charlie Jenkins, already known in Bryan for constructing many homes and churches in the city, was the fire chief (sitting in the truck at right and wearing a white hat).

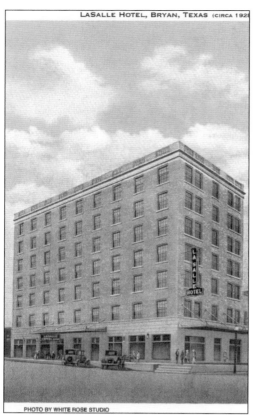

The LaSalle Hotel was built in 1927 at a cost of $250,000 and is now a downtown landmark. Originally owned by R. W. Howell, the LaSalle is now connected to the adjacent Howell Building via an entrance plaza designed for convenient access for hotel guests. The City of Bryan purchased the LaSalle and renovated the building as part of the recent downtown revitalization project. On May 26, 2000, the LaSalle Hotel was added to the National Register of Historic Places. (Courtesy of the Downtown Bryan Association, Inc.)

The Bryan Boosters were Main Street businessmen who worked hard to keep business local by organizing caravans, known as "Trade Trips," into the Brazos Bottom to sell their products during the late 1920s and early 1930s. This photograph shows the west side of Main Street, with the tall building on the right being the Astin Building on the corner of Twenty-sixth Street.

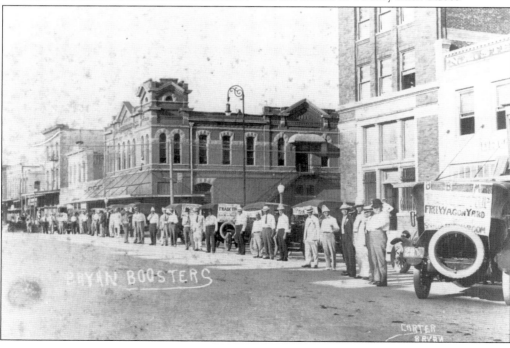

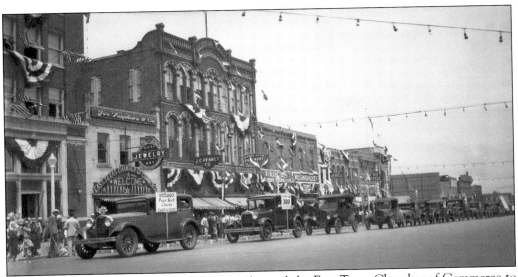

In 1929, Bryan was in a festive mood as it welcomed the East Texas Chamber of Commerce to town with a big parade. The sign on the first car advertises a burgeoning poultry industry: "225,000 pure bred chicks placed on farms." Among the businesses along Main Street are, from left to right, the City National Bank, Joe Kaplan and Company, J. C. Penney, Parker-Astin Hardware, Brocks, Wilson Bradley, Caldwell Jewelers, H. B. Shoes, and the First National Bank.

This is the fifth, and most beloved, courthouse in Brazos County's history. It was designed by architect Eugene T. Heiner, built in 1892, and adorned with a Seth Thomas clock. A wrecking crew led by Ted Hall from Iowa demolished this courthouse in 14 days in August 1954. The first thing to hit the ground was the Seth Thomas clock. The current concrete-and-glass courthouse was designed by architectural firm Caudill, Rowlett, Scott, and Associates of Houston and occupies the same location at Texas Avenue and Twenty-sixth Street. This photograph was taken after the snowstorm of 1937.

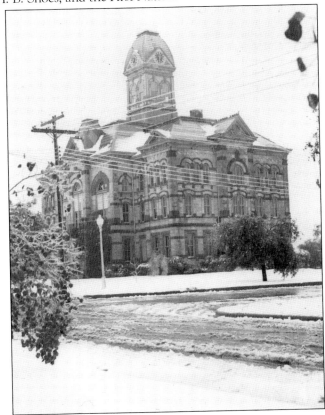

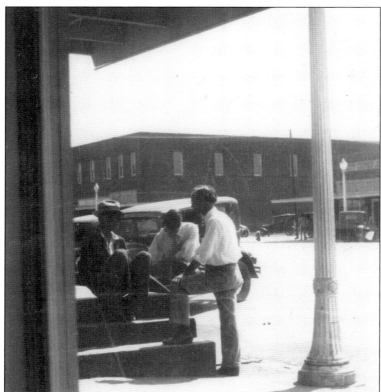

This May 1933 photograph on North Main Street shows the high sidewalks, which were popular during this era, in front of D. Mike's grocery. Their purpose was to serve as an unloading dock for merchandise as well as for the convenience of foot traffic. The three men in the picture worked at the grocery. The large building across the street was a competitor, Sebesta's.

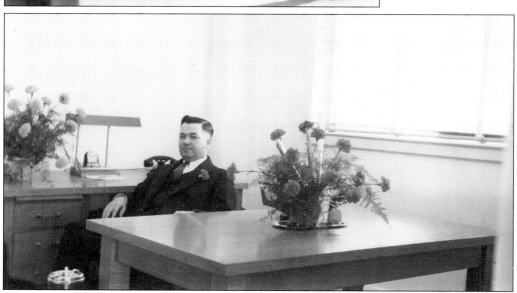

Travis Bryan was president of the First National Bank of Bryan from 1933 to 1964. This photograph was taken in October 1939. As a market town, both banks and bankers have been important to the town's development. The Bryan family has been prominent in banking in Bryan since the town's inception. Notice the bouquets of fresh flowers, the boutonniere on Bryan's lapel, the rotary phone on his desk, venetian blinds over the window, and the floor ashtray by his table.

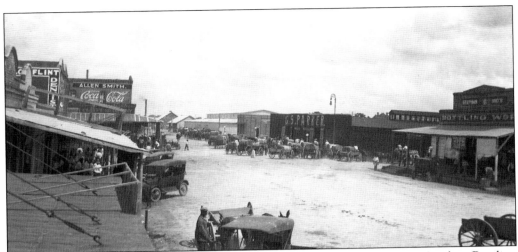

The north end of Main Street bustled with minority businesses. To the right is Stephan Bottling Works and the Colored Drugstore, a vestige of segregation. In the center is the Parker Gin and Cotton Warehouse. To the left is the Smith Allen Building, home to Joe Zemanek's Grocery and Feed Store during the late 1940s and 1950s. Zemanek's offered customers free samples of cheese and summer sausage, rural grocery delivery, and use of the limited telephone and restroom facilities on that block.

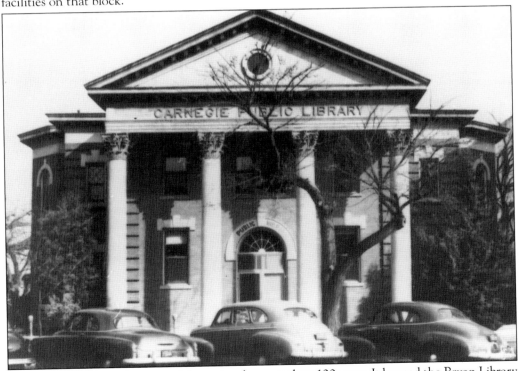

The Carnegie Library has served the region for more than 100 years. It housed the Bryan Library from its opening in 1903 until 1969, then was used by the City Planning Department. In 1999, the building was renovated and reopened as the Carnegie History Center, remaining, to this day, a member of the Public Library System of Bryan and College Station.

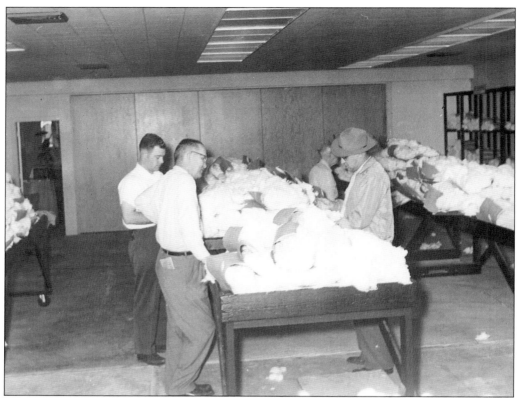

The influence of cotton, the driving force behind Bryan's economy since the town's founding, continued into the 1950s. This was the B-L-D Agency's sample room, where cotton buyers graded cotton samples according to such factors as staple length and whiteness in order to determine pricing. Today the federal government has taken over the job of grading cotton.

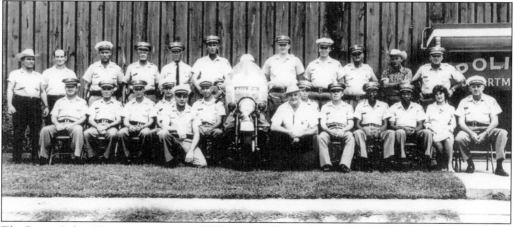

The Bryan Police Department was established in 1869, but due to early fires in city hall, the earliest known surviving group picture of the Bryan Police Department was taken in 1960 in front of the police station on South Main Street. The chief of police, Lawrence L. Martin, is kneeling to the right of the motorcycle officer. He was killed in a plane crash on June 28, 1961, along with traffic sergeant Richard McDaniel. (Courtesy of the Bryan Police Department.)

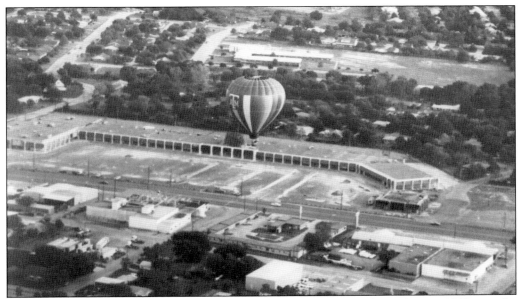

The Townshire Shopping Center on Texas Avenue in south Bryan, shown here in 1982, was the first regional shopping center in Brazos County. It opened in 1958 and began a trend of Main Street businesses moving to strip centers between Bryan and College Station. John C. Culpepper and his son John C. Culpepper Jr. developed numerous local real estate projects. Behind the center is Henderson Elementary.

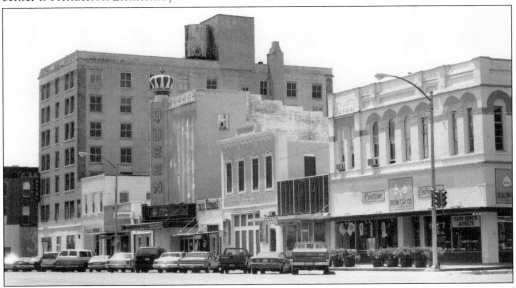

This 1994 photograph shows the west side of the 100 block of Main Street. Since then, parts of downtown have undergone extensive revitalization. Renovations to restore the Queen Theater into a community entertainment venue have begun. The 550-seat Queen opened on November 21, 1939, with a showing of *Fifth Avenue Girl*, starring Ginger Rogers. The *Daily Eagle* stated, "At the time of its grand opening, the theater had the latest equipment and shades of rose, blue, and peach lights highlighted the interior." The two-story building in the center was formerly the Dixie Theater, popular for showing Westerns on Saturday afternoons.

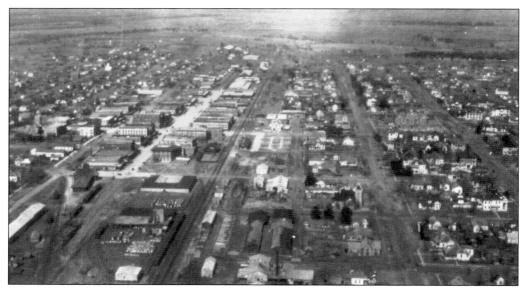

This is a relatively early aerial image of Bryan, looking to the north. Along the railroad tracks, the downtown area is flanked by cotton warehouses both to the north and to the south, indicative of cotton's importance to Bryan's economy. East of the track in the center of the photograph is the city park. The large building to the right is the courthouse, and the small white church to the far right is the first St. Joseph Catholic Church.

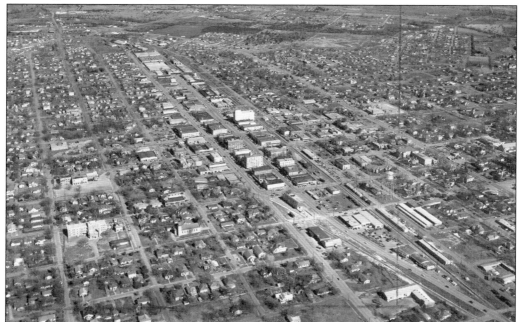

This c. 1955 aerial photograph of Bryan was taken looking to the north. The large light-colored structure in the center is the Varisco Building, built by Brazos Varisco in 1947. At far right of the image is the St. Joseph Church and School, which was replaced with a new church building in 1950. In between is a hole in the ground where the old courthouse was demolished. The current courthouse was built on this site and opened in 1957.

Two

CHURCHES, SCHOOLS, AND ORGANIZATIONS

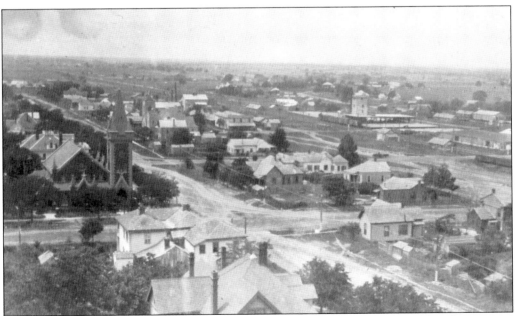

This chapter begins with this image because it illustrates how accessible the churches were to Bryan's homes, its businesses, and its courthouse. The brick sanctuary to the left belongs to the First Baptist Church and was built in 1905. A block back and across Washington Street is the First Presbyterian Church. Behind that are two smokestacks of the Garth, Howell, and Webb Corn Mill and Cotton Gin. To the right is the Bryan rail yard, and across the tracks is the Bryan (Cotton) Press Company at the south end of Main Street. At the far right of the photograph is a depot. This view is looking to the south from the courthouse.

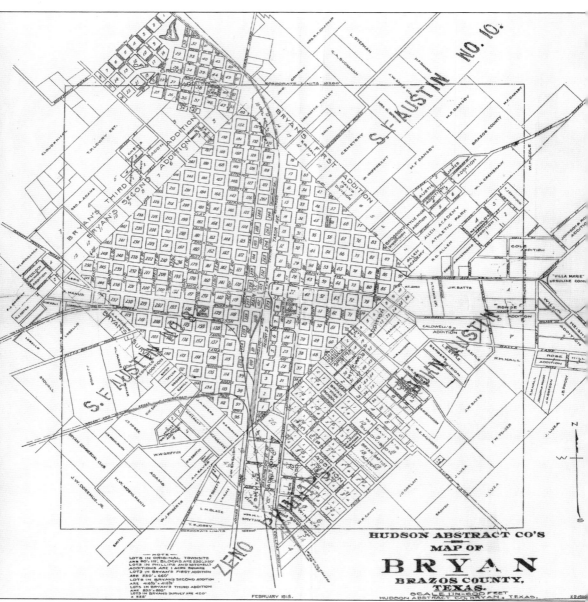

This 1915 map locates Bryan's early schools. Southeast of downtown, on Lamar Street (now Twenty-ninth Street), is the old Bryan High School (now the site of Fannin Elementary), which was the first public school in Bryan. A few blocks west of downtown, between Anderson Street and Burleson Drive (now Twenty-sixth and Twenty-seventh Streets), was the West Side School (now the site of Bowie School). Northeast of downtown, between Jackson and Clay Streets (now Martin Luther King Boulevard and Twentieth Street), is what was called the Colored School. It later became Washington Elementary. In 1971, it was destroyed by fire and not rebuilt, as black students were integrated into the Bryan Public Schools. Today it is the site of the Brazos Valley African American Museum. A short distance to the east was Allen Academy. To the south, near the old Bryan High School, was the Bryan Baptist Academy, between Monroe and Adams Streets. On the eastern edge of the map was the Villa Maria Ursuline Academy.

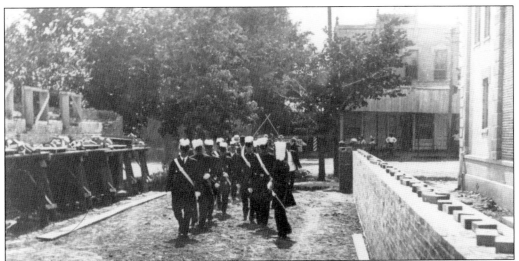

The Freemasons organized in Brazos County in 1852 and were chartered in 1854. Their first lodge was a building shared by Masons, churches, and a school in Boonville. In 1902, Free Baptists bought the Masonic Lodge for a school. On June 15, 1910, the cornerstone was laid for a new Masonic Lodge at 107 South Main Street in Bryan. Many of Bryan's early prominent citizens were Masons.

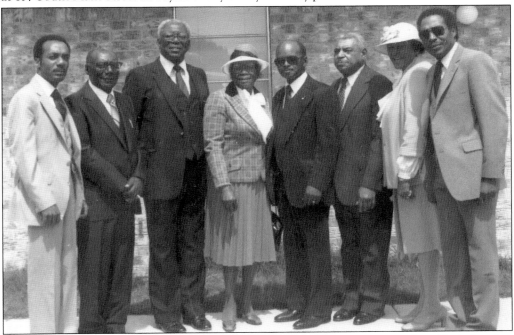

The Shiloh Baptist Church has roots that go back to 1860. Before construction of any black churches in Bryan, worshippers met at the "Brush Arbor" on alternate Sundays. On East Nineteenth Street in northeast Bryan, two lots were purchased on March 2, 1870, and a worship hall was built for the Bryan Baptist Church. The name was changed to Shiloh Baptist Church in 1885, when a new structure was built at this location. Members of the Shiloh Baptist Church Finance Committee, shown here from left to right in a recent photograph, are Carl Idlebird, Willie Idlebird Sr., Willie Pruitt Sr., Julia Rouse, Paul Peterson, Olemuel Davis, Doris Scurry, and Pastor L. W. Turner.

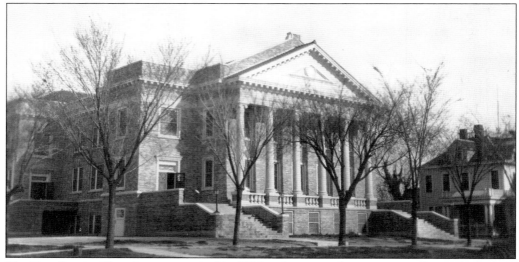

The First Baptist Church was organized in 1866 and met in a former tenpin alley and saloon as well as in an auditorium with a partition down the center separating the men and women. In 1884, the congregation moved to Burleson Drive (now East Twenty-seventh Street) and Washington Street, erecting a wood-frame building in 1884, a brick sanctuary in 1905, and the brick structure in this photograph in 1927. The Baptists had the first pipe organ in town. It was a Lyon and Healy organ from the Watkin Music Company of Dallas. The public was invited when W. A. Watkin himself came to give the inaugural performance on July 24, 1901. In 2000, the church moved from downtown to the Eastgate area closer to College Station, near the Highway 6 Bypass.

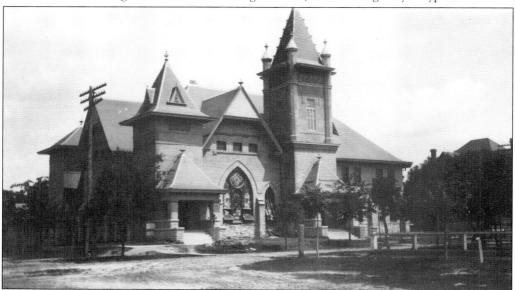

In about 1867, the First United Methodist Church was organized as the Methodist Episcopal Church on land donated by William Joel Bryan. The original building on East Twenty-eighth Street (then Fannin Street) cost $500 and was used until 1902, when this magnificent structure was built. The sanctuary was destroyed by fire in 1906. Within two years, the church was rebuilt using the same plans and served the congregation until being replaced with the present sanctuary at the same location in 1951.

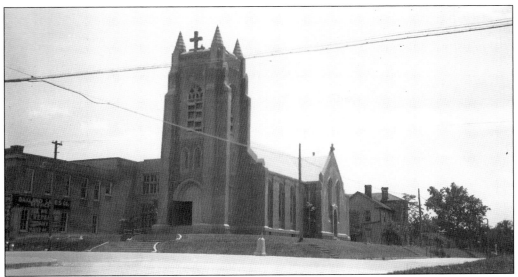

St. Andrews Episcopal Church began in Millican in 1864, then came to Bryan three years later. Originally at the corner of Moseley and Red Top Streets, it moved a block south to Red Top and Anderson Streets (now Parker and Twenty-sixth Streets). Charles Jenkins built the sanctuary in this photograph between 1912 and 1914 at a cost of $40,000. Early congregants included members of the Astin, Parker, and Chance families. In 1938, lightning struck one of the church towers, and Jenkins repaired the damage with metal shingles saved from the original construction.

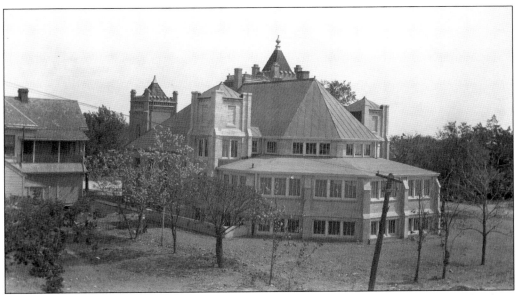

The First Presbyterian Church organized in Bryan in November 1867, and members met for three years in Guy M. Bryan's warehouse by the railroad before building a church at the corner of Tabor Road and Lamar Street (now Twenty-ninth Street). Adjacent land was acquired on Washington Street, and in 1906, the sanctuary in this photograph was built. When modernization was deemed necessary, the Cavitts donated land for a new church. In 1956, the ground-breaking was held at a new site south of Gordon Street, between Thirty-first and Thirty-second Streets.

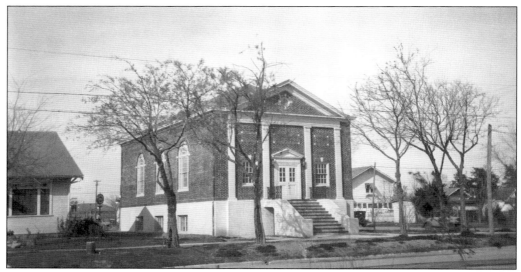

The First Christian Church was organized in the late 1860s and held services in private homes and stores. The church's first building was located on the corner of Twenty-seventh Street and College Avenue (now Texas Avenue) on property donated by W. J. and Cornelia Proctor in 1877 and was used until it was deemed "out of repair" in 1907. For several years, services were held in the opera house. The church seen in this photograph was completed in early 1911.

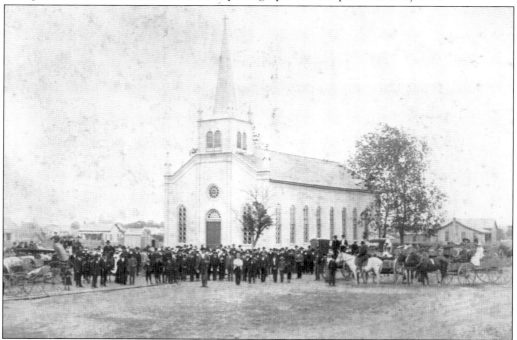

St. Joseph Parish was organized in 1873 and dedicated its first church building, shown here, in 1878. Their first sanctuary was destroyed by fire, and for a while, the second floor of the Dunn and Daly Building on Main Street was used as a meeting place for the parish. A second sanctuary was dedicated in 1904 and served the parish until the present modernized building was completed in 1960. (Photograph from *St. Joseph Parish, Bryan, Texas: 100th Anniversary, 1873–1973*.)

A&M College held its first classes on October 4, 1876, at its present site in College Station, 4 miles south of Bryan, on land donated by a group led by Harvey Mitchell. It began as the Agricultural and Mechanical College of Texas with an all-male enrollment of 106 cadets and has grown into one of the largest universities in the nation, with a coeducational enrollment of more than 45,000 students.

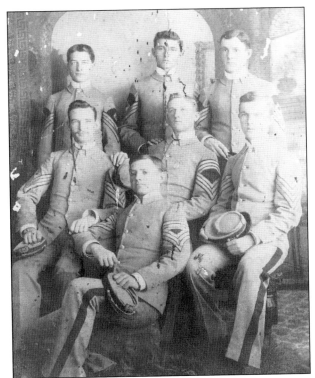

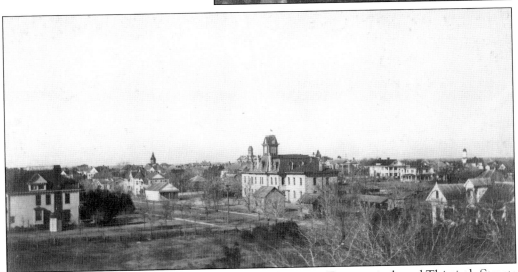

Bryan's first public school opened on Baker Street, between Twenty-ninth and Thirtieth Streets (then Lamar and Monroe Streets), in 1880 and was called the Bryan Graded School. The first two floors were classrooms, and the third floor was an auditorium, gymnasium, and chapel. The west side of the schoolyard was for boys, and the east side was for girls. Each had their own covered arbor with a cistern for drinking water, which was where students ate lunches brought from home. For a while, it was known as Bryan High School. Some of the smaller buildings around the perimeter were used as music studios. Today it is the site of Fannin Elementary School in the Eastside Historic District.

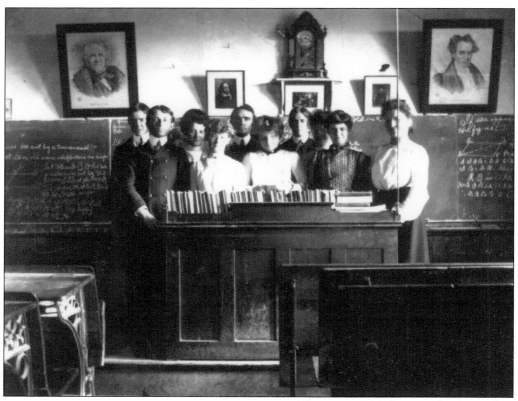

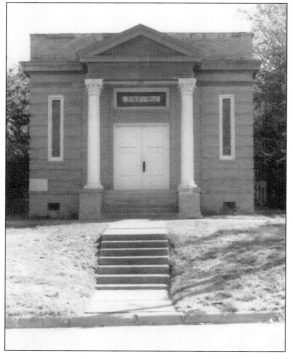

This is an 1896 photograph of one of the classrooms in the original Bryan High School. Note the geometry lesson on the chalkboard and portraits of Sam Houston, William Shakespeare, and Stephen F. Austin on the wall.

Temple Freda is a Jewish synagogue located in the 200 block of South Parker Street. The congregation was organized in 1890. It is unusual in that it is named for a woman, Ethel Freda Kaczer, the deceased wife of the congregation's first president. Although the Jewish community in Brazos County was small, it had the support of a larger group in the area. J. W. English donated the land "for religious or beneficial purposes." In acknowledgement of this act of good faith, Temple Freda allowed other small religious groups to meet in their facility until they could provide their own place of worship.

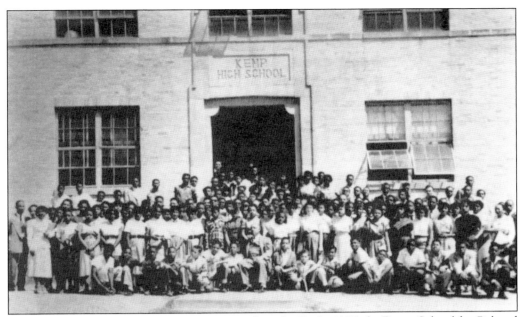

Public schools in Bryan were racially segregated until 1971. In 1885, the Bryan School for Colored opened on East Nineteenth Street at Preston Avenue and operated on that block until 1971. Its name was changed to Washington Elementary in 1930, when Kemp Junior and Senior High School was built on West Nineteenth Street to serve black students. In 1961, a new Kemp High School was built. (Courtesy of Diane Peterson Smith.)

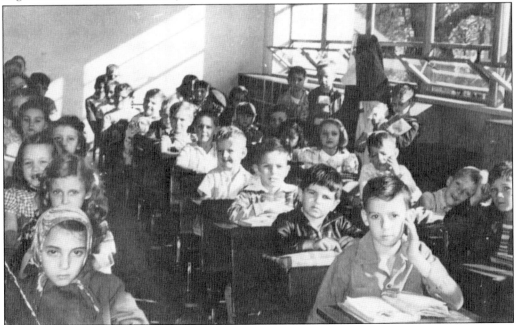

St. Joseph Parochial School opened in 1895 and was replaced with a newer school in 1936. This image is from about 1926, when the nuns from Ursuline Academy also taught at St. Joseph's. (Photograph from *St. Joseph Parish, Bryan, Texas: 100th Anniversary, 1873–1973*.)

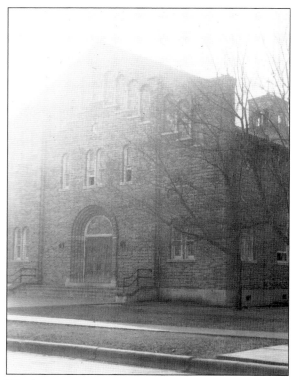

St. Anthony's Catholic Church was founded in 1896 with 100 Italian families and has grown to serve more than 700 families. Its first sanctuary on Polk Avenue was a white frame building that was destroyed by fire in 1926. This sanctuary was built in 1927 at 306 South Parker. In 1987, St. Anthony's was added to the National Register of Historic Places.

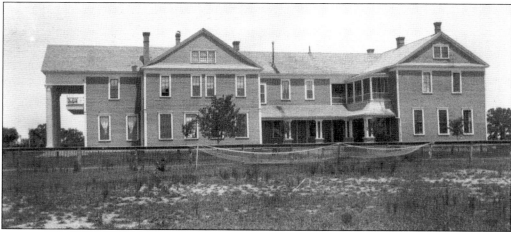

Allen Academy is a private school that was founded by John Hodges Allen as Madison Academy in Madisonville in 1886. The school was renamed the Allen Academy when it moved to Bryan as a boys' college preparatory school in 1899. Bryan's location on the railroad and its proximity to the all-male A&M College were factors in the move. The academy was located near Ursuline Avenue and Twenty-second Street on the east side of town. Military training was added in 1917 and continued as part of the curriculum until the 1980s. In 1970, the first Blinn College classes in Bryan were held at Allen Academy. In 1988, their Ursuline Avenue campus was sold to the Federal Bureau of Prisons. Allen Academy moved to a new campus on Boonville Road, east of the Highway 6 Bypass, and also began admitting girls into a pre-kindergarten through 12th grade college preparatory curriculum.

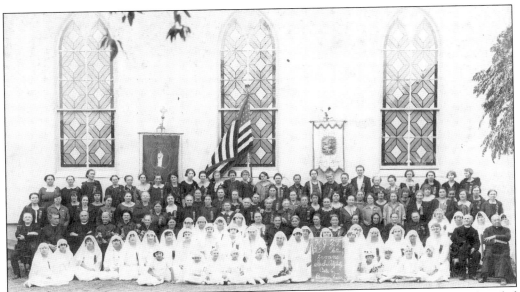

St. Elizabeth Society KJZT No. 6 is a Catholic women's insurance fraternal organization, founded by immigrant Czech women in Bryan on November 1, 1899. The Bryan chapter was named for St. Elizabeth of Hungary, helper of the poor. Today the group is known as the Catholic Family Fraternal of Texas (originally the Ceska Katolicka Jednota Zen Texaskych, meaning "Union of Czech Catholic Women of Texas) and continues to provide life insurance, annuities, and home loans to members while striving to preserve Czech heritage through strong ties to the Catholic Church. This photograph was taken on the occasion of the 25th anniversary of the founding of the Bryan society. (Courtesy of Liz Zemanek.)

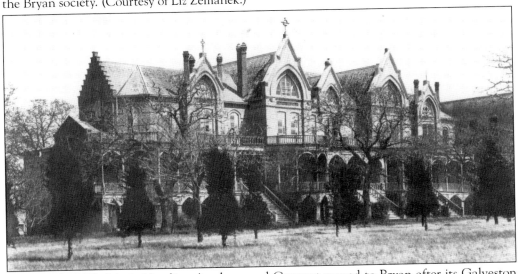

In 1901, the Villa Maria Ursuline Academy and Convent moved to Bryan after its Galveston facility was destroyed during the hurricane of 1900. The Sisters of the Ursuline Order taught at both the Villa Maria Academy for girls as well as St. Joseph's Catholic School. In spite of a beautiful 50-acre campus that was connected to Main Street via an interurban trolley in 1913, the academy was never able to enroll enough students to sustain itself. In the summer of 1929, the Sisters moved back to Galveston, where their convent had been restored.

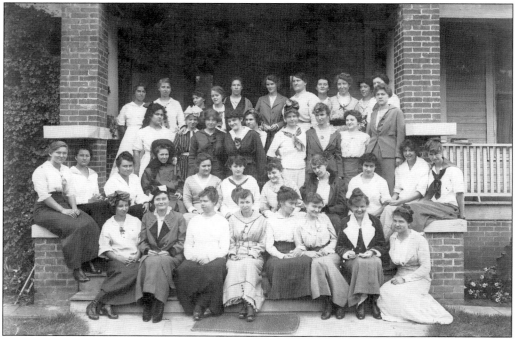

Bryan Baptists founded the Texas Women's College in 1905. Dr. George B. Butler, pastor of the First Baptist Church, served as its first president. In 1909, it became the Bryan Baptist Academy, and Prof. R. McDonald served as its president. The academy's operations were discontinued in 1914, and in 1918, the property was sold to Eugene Edge.

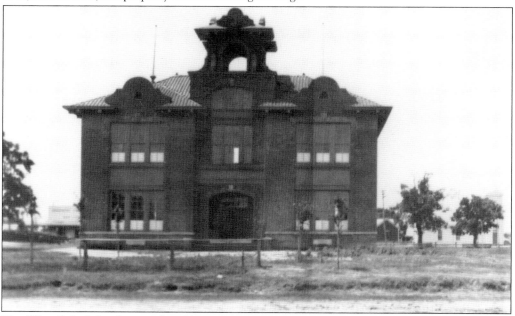

The West Side School opened on Twenty-sixth Street in 1905 to relieve overcrowding and keep younger children from having to cross the railroad tracks to get to school. Charles E. Jenkins built the school. The newer, but now abandoned Bowie School occupies this site.

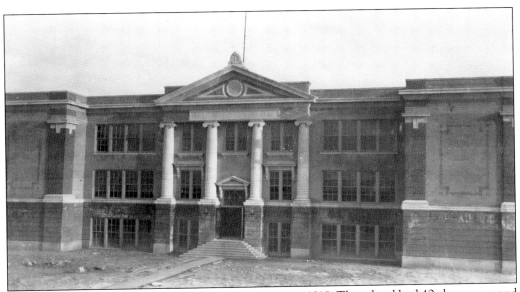

Fannin High School was constructed on Baker Street in 1918. The school had 40 classrooms and an auditorium that seated 1,000. It replaced the original Bryan Public School that was built in 1880. Today it is the site of Fannin Elementary School. In 1907, Bryan High School had 48 students and two teachers following a three-year curriculum that included English, mathematics, history, and Latin. All students took the same courses and were expected to pass all four of their courses in order to be promoted to the next grade level. By 1915, Bryan High School had 162 students and seven teachers. The curriculum included English, mathematics, history, Latin, German, physics, agriculture, manual training, home economics, and offerings from a commercial department. The curriculum was extended over four years, and students were promoted by departments rather than on the basis of their entire course of study.

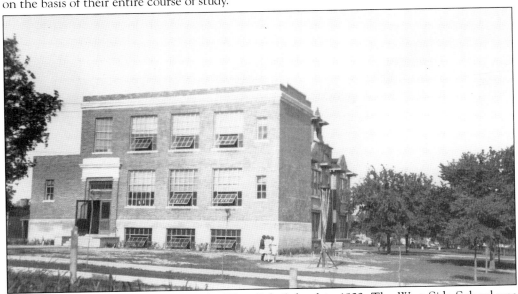

Bowie School was built adjacent to the West Side School in 1922. The West Side School was razed for the construction of a gymnasium for Bowie. As of this writing, the Bowie School is boarded up and for sale.

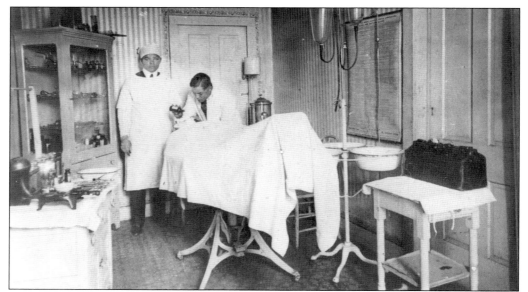

In 1929, Dr. William A. Hammond Sr. opened Hammond Memorial Hospital at the corner of Seventeenth Street and Randolph Avenue. Dr. Hammond operated this hospital for the benefit of the African American community until the 1950s.

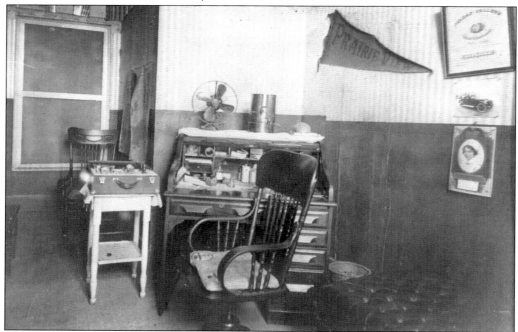

Dr. Hammond's office was adorned with a Bishop College diploma, a Prairie View banner, roll-top desk, and physician's bag for house calls. Bishop College was a black Baptist college in Marshall, Texas, and Prairie View A&M is a land-grant institution established for black students in Prairie View, Texas, between Bryan and Houston. Dr. Hammond was a graduate of Prairie View. At the time this photograph was taken around 1920, physician J. G. Osborne was Prairie View's president, and the institution added nursing, medicine, and veterinary studies to its curriculum.

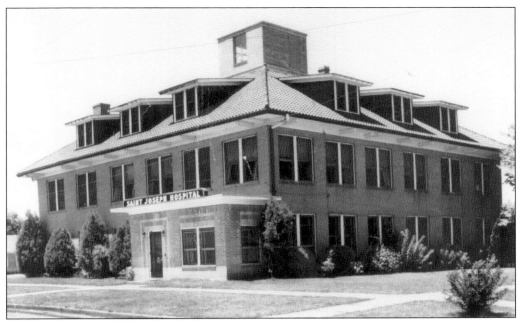

Bryan Hospital got its start in 1913 under Dr. W. H. Oliver. The hospital's history was not well documented until it was purchased by the Sisters of St. Francis and reopened as St. Joseph's Hospital in 1935.

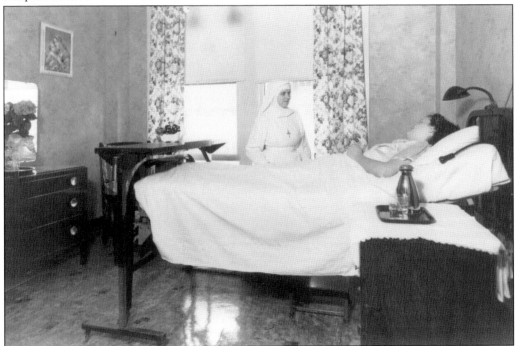

A new wing was added to St. Joseph's Hospital in 1954, and an entirely new hospital was built in 1971 at Villa Maria Road and Twenty-ninth Street. This facility was expanded significantly in the last 10 years.

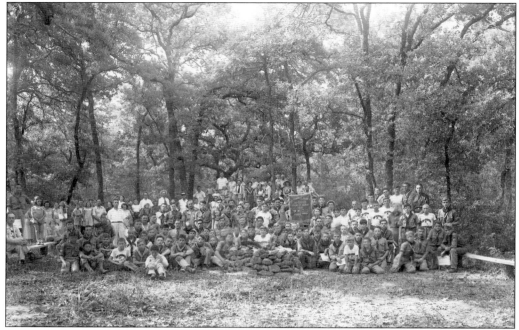

Camp Arrowmoon is the pine-forested Boy Scout camp in southern Robertson County that has served several generations of Bryan scouts. This photograph is from an honor court in 1949. The Waldrop and Parks store carried scout uniforms.

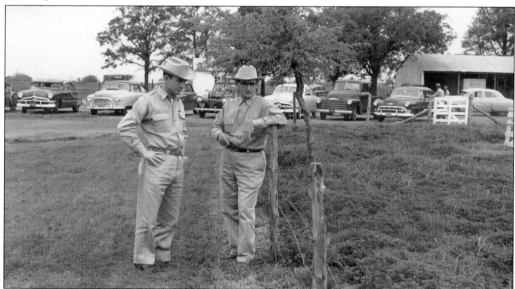

Local law enforcement agencies include the Bryan Police Department and the Brazos County Sheriff for unincorporated parts of the county. Another group vested with law enforcement authority is the Texas and Southwestern Cattle Raisers Association. Established in Texas in 1877, the TSCRA field inspectors have legal authority with regard to apprehending livestock thieves. In this early-1950s photograph a broken fence was being inspected, possibly in response to a suspected cattle-rustling operation.

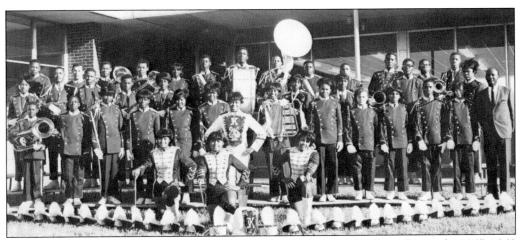

William D. Portis directed the Kemp High School band, photographed here during the 1967–1968 school year. In September 1971, a new Bryan High School opened that was racially integrated. Kemp School was then designated as a school for sixth grade students. (Photograph from *The Bruin* yearbook; courtesy of Diane Peterson Smith.)

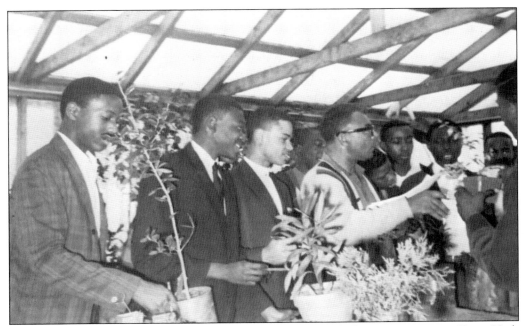

Plant identification in a greenhouse was part of the agricultural education program at Kemp High School. (Photograph from *The Bruin* yearbook; courtesy of Diane Peterson Smith.)

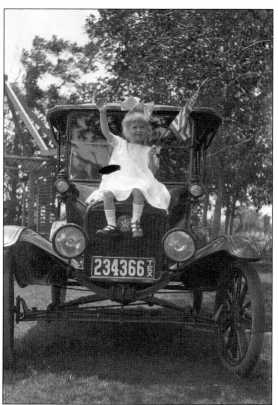

The Brazos Heritage Society was created with the goal of preserving the cultural heritage, architecture, and historical context of Brazos County. Past projects include the establishment of Heritage Park, an annual Fourth of July children's parade, publications, Holiday High Tea, historic home tours, support for other groups working to preserve local history, and *Heritage Highlights*, a weekly radio broadcast.

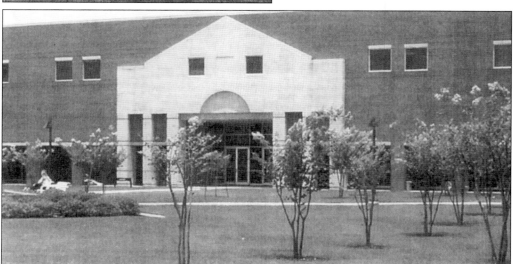

Blinn College was founded in Brenham in nearby Washington County on March 28, 1883, as a mission of the German Methodist Church. In 1937, it became the first county-owned junior college in Texas. In 1970, the school began offering night classes at the Allen Academy in Bryan and the A&M Consolidated High School in College Station. In 1997, Blinn built its own Bryan campus, shown in this photograph, on Villa Maria Road, near East Twenty-ninth Street. In the spring of 2009, Blinn College in Bryan had an enrollment of 10,500 students.

Three

LIFESTYLES AND LEISURE

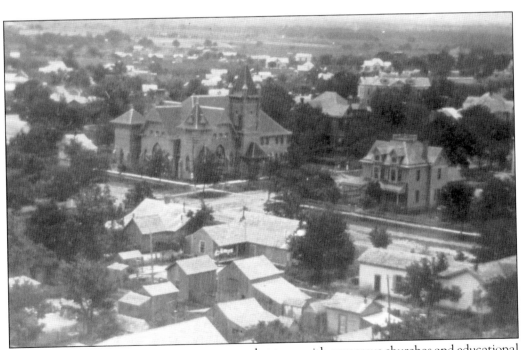

By the early 1900s, Bryan was a prosperous market town with numerous churches and educational institutions. This photograph of the Methodist church shows it to be surrounded by homes from all walks of life. Culturally, however, the people were still segregated between races and economic levels. One activity that brought everyone together was a parade. Parades were held to celebrate the kickoff of the annual fair, the completion of a new railroad route, May Day events, patriotic events, holidays, and even welcoming the East Texas Chamber of Commerce for a visit.

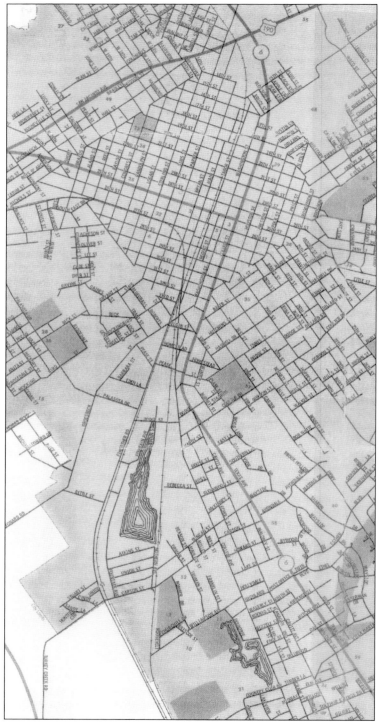

This 50-year-old map was selected to show the relationship between Bryan's Main Street and Finfeather Lake, located between the railroad tracks south of downtown.

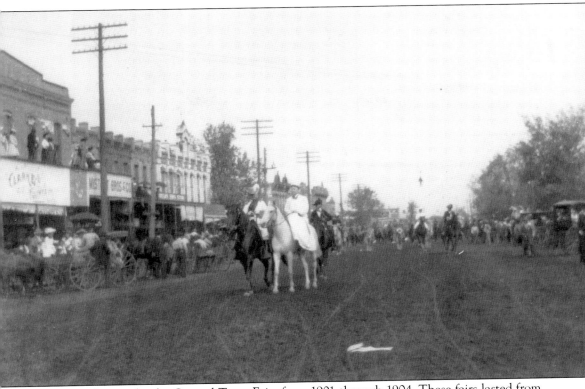

Bryan was the site for the Central Texas Fairs from 1901 through 1904. These fairs lasted from three to four days and were always preceded by a grand parade. They had exhibits of local and regional products and demonstrations as well as racing, roping, and shooting contests. The 1902 fair featured a sham battle consisting of three companies of the Texas Volunteer Guard and the 17th Battery (flying artillery). The program closed with a balloon ascension. The aeronaut (hot air balloonist) released rabbits with small parachutes, fired bombs into the air, and made a grand parachute leap. At the 1903 fair, Will Pickett, who is now in the Black Cowboy Hall of Fame, tossed a wild steer by grabbing its nose with his teeth, and Adolph Topperwein, the Champion Trick Shot of the World, shot pieces of bricks thrown into the air, breaking them into shards and then hitting the broken pieces before they reached the ground. During at least one Central Texas Fair, a football game between A&M and Baylor also took place. Typically the Central Texas Fair included a farm and dairy department, with items such as maze, field-grown hay, open-range hay, watermelon, cantaloupe, pumpkin, fodder, different types of corn, and ribbon cane. In addition to a variety of baked and canned goods, vegetables including tomatoes, squash, turnips, rutabaga, parsnips, cabbage, lima beans, cauliflower, cucumbers, eggplant, lettuce, horseradish, onions, parsley, peas, and pungent pepper were also shown. Livestock exhibits featured a wide variety of hogs, cattle, horses, and goats, and there were large poultry exhibits that included Plymouth Rock chicks, silver wyandottes, black Langshan fowls, brown leghorn fowls, game bantams, bronze turkeys, Pekin ducks, and pigeons. Belgian hares and guinea pigs were some of the pet stock on display. There were also exhibits in the art, textile, and culinary departments as well as local merchants' displays of groceries, hardware, furniture, dry goods, gents' furnishing goods, and wagons. For the ladies, there were exhibits and prizes in textiles, including best crochet baby caps, point-lace dress trimming, sofa pillows, Battenburg table covers, and embroidered centerpieces as well as hemstitching and drawnwork, quilts, and knitting. Art such as pastels, photographs, pencil drawings, and pen and ink work was also on display.

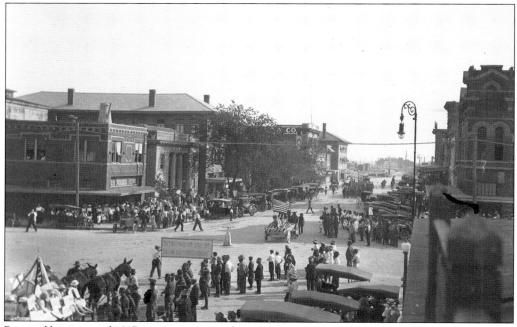

Pictured here around 1917 is a patriotic parade at the intersection of Twenty-sixth and Main Streets.

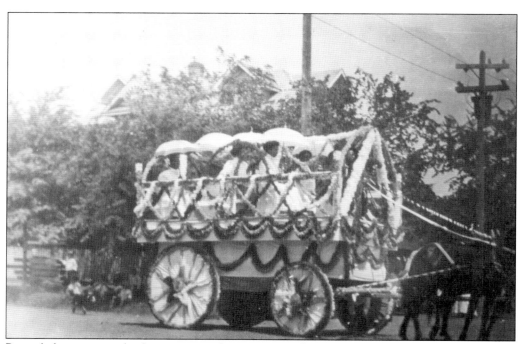

Bryan ladies were involved in preparing the community for World War I. They organized patriotic meetings and food clubs that promoted food preservation to ensure that the Brazos Valley residents did not go hungry during the war years. They also sponsored colorful floats in local parades.

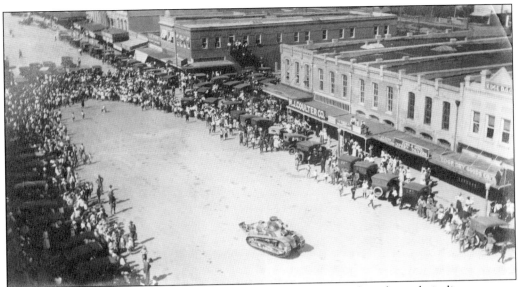

Although a World War I tank holds the interest of the town, residents keep their distance.

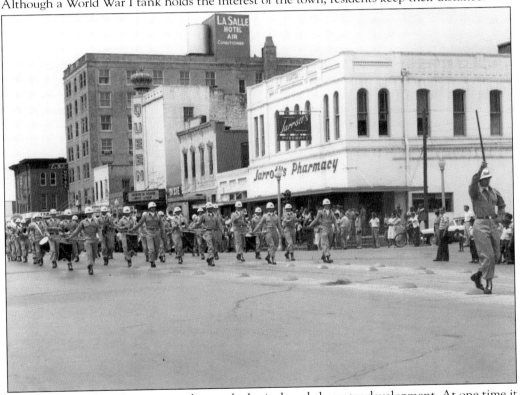

Allen Academy has always stressed mental, physical, and character development. At one time it was an Honor Military School. Although all area sports were played, the school was a pioneer in track, establishing the first 400-meter cinder track in the state. In 1975, the Texas Private School Foundation assumed ownership. In this 1950s photograph, Allen Academy cadets proudly march up Main Street.

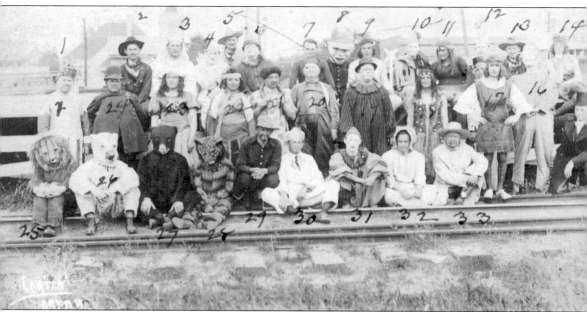

Instrumental to Bryan's growth and development was its many and varied clubs. Their source of funding came from the members, grants, and contributions as well as individual projects. In a welcome relief from the worries of the day (World War I), the Elks Club of Bryan put on a fundraiser in 1917 that was the talk of the town. Billed as the "66 Ranch and Humbug Circus," the performers were some of Bryan's prominent citizens. A waterproof tent that seated 3,000 was acquired for this "Show Cus." Taking great delight in the actors' silly antics, the town laughed with them as they cavorted around in ridiculous skits, such as those described in the *Daily Eagle*: Clad in spangled, mustard green tights, with piped cerise trunks, "Extraordinary Erwin" (president of the City National Bank E. H. Astin) waltzes in to the tune of "Pretty Baby," whistled by Jack Gordon and Judge Joe Maloney, to save "Big Bill" (postmaster Will Lawrence) as he dangled from a tent pole. "Mirthful Mit" (Milton B. Parker) was the chief clown. Mit selected a staff with ability in keeping with his own talent. Famous Roman chariot races were recreated with Lamar Bethea appearing as "Ben Hur" and Walter Coulter as "Ben He." "Charming Charlie" Hudson as "Princess Wicky Wacky Woo" swayed to the ukulele strummed by Christopher Columbus Seale of the Benchley Symphony Orchestra. Lauded as "a thing of beauty and a joy forever," the "Dance of the Fairies" was performed by H. C. Fulgham representing "spring," John Vick impersonating "Love," and Joe Batts, with his grace and regal bearing, assuming the role of "Queen O'May." In addition, there were jungle beasts, Oriental dancing girls, elephant trainers, lion tamers, bearded ladies, Hindu harem girls, lady bareback riders, and dozens of other burlesque characters. "Pearless Pete" Saunders completed the hilarity by shooting the eyelash off a "fly in the ointment."

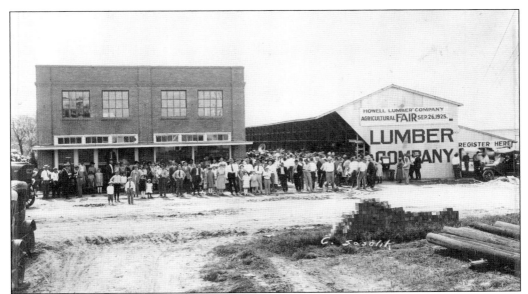

During the 1870s, Harvey Mitchell organized the Central Texas Agricultural and Mechanical Association with the purpose of holding at least one county fair every year. This fair was held at Howell Lumber Company in 1925.

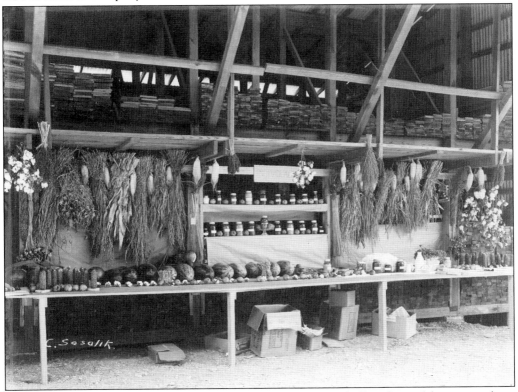

Local products were showcased at the county fair. Note the cotton bolls in front of the watermelons, both still major agricultural products in the region today.

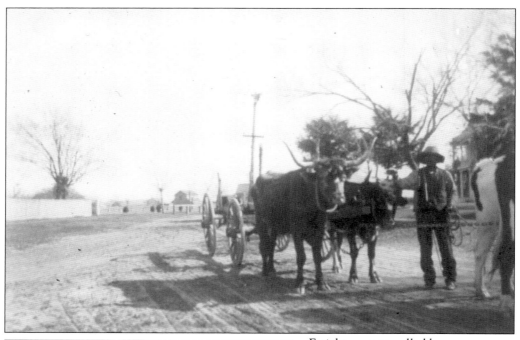

Freight wagons pulled by oxen were a familiar scene on Bryan's dirt roads. The major streets were constructed wide enough so that teams such as this could turn around without having to back up.

Ribbon cane crops increased in early 1900 as the Brazos Valley farmers began making a high-grade open-kettle molasses, thereby upping the demand. Some farmers deviated from the customary barrels and jug containers, opting to use neatly labeled cans of various sizes. This brought increased profits. With similar results in profits, they stopped selling cattle by the head and chickens by the dozen and started selling both by the pound.

Woodrow T. J. Speake Minnie

Few things stir a Texan's pride like horses and bluebonnets. Events in horse racing, riding, and roping were main attractions at fairs and, later, rodeos. Popular contests at the Central Texas Fairs were running (half-mile dash), pace (1-mile heat), trotting (half-mile heats), and pony racing (quarter-mile dash). Fairs also provided a marketplace. The following is from a fair advertisement: "Trotting and pacing horses handled for speed, as well as Gentleman roadsters and family carriage horses."

In the spring, roadsides and pastures in the Brazos Valley abound in bluebonnets, the state flower of Texas. Photographing loved ones in a field of bluebonnets has long been an honored Texas tradition.

A horse trained to work cattle was a necessity on any ranch. Today a paint horse such as this one is the symbol of Bryan's Catalena Cowgirls. In 1975, the Sammy Catalena Rodeo Company was organized. In 1990, the Catalena Cowgirls were added to bring a spectacular flair of precision-riding pageantry to the national anthem at the start of each rodeo.

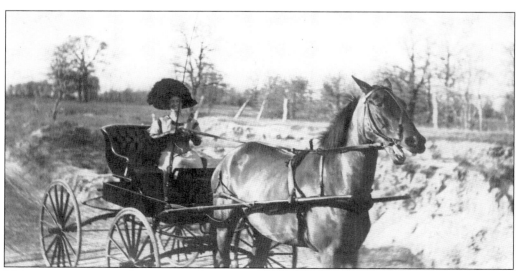

This woman appears to be posing on her way into town. One wonders how much she really knew about driving a horse—she has the reins tight enough that the horse is objecting—and if she retained her enthusiasm for driving when the horseless carriage arrived on the scene.

The strong personalities of these women was often seen among the ladies of Bryan, as they exerted significant influence on the town's early development. One of the many clubs dedicated to both personal and community growth was the Mutual Improvement Club of Bryan, later known simply as the Women's Club. In 1901, at the end of a report, Pattie Sims told the attendees, "The ambition of our circle is to do noble things, not dream them all day long."

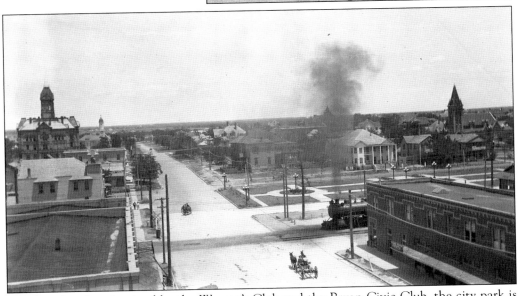

Developed and maintained by the Women's Club and the Bryan Civic Club, the city park is visible in this 1916 image looking east along Twenty-sixth Street. The city park was the site of Bryan's first public Christmas tree lighting in 1916. Across the park is a row of hotels. The white, columned structure in the center is the Central Hotel.

On the upper floor of the Carnegie Library was a children's library, where Bryan youngsters spent many enjoyable hours. The library's early contributors of books and furnishings were the Mutual Improvement Club, the Daughters of the American Revolution, and the Shakespeare Club. Kate B. Parker Oliver was the president of the local Shakespeare Club. In addition to her personal contribution to the library, she asked members not only to give, but also to earn their library donation through their own efforts.

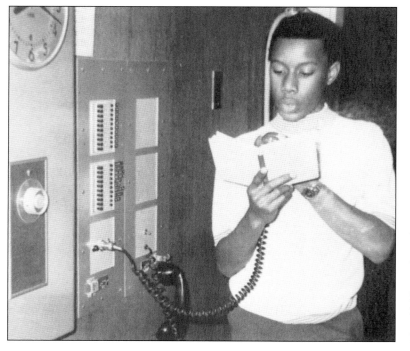

Willie Pruitt is using the intercom to broadcast the daily devotional to his classmates at the still segregated Kemp High School in 1967. Religious practices have held an important place in the lives of many Bryan residents.

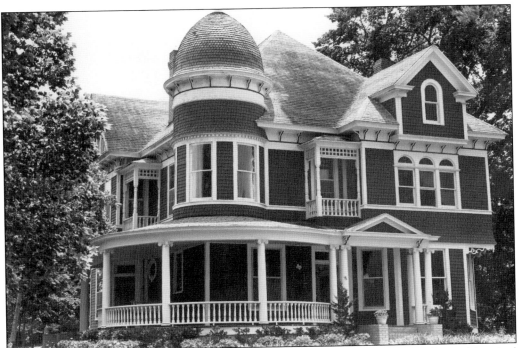

Great pride is taken today in the richness of Bryan's architectural heritage. One of many historical sites, this Queen Anne structure is located at 607 East Twenty-seventh Street. Charlie Jenkins built the home as a wedding present in 1895 for a younger brother, Edwin James, and his bride, Ella Pink Williams. Edwin, a druggist, served on the Bryan City Council and as mayor.

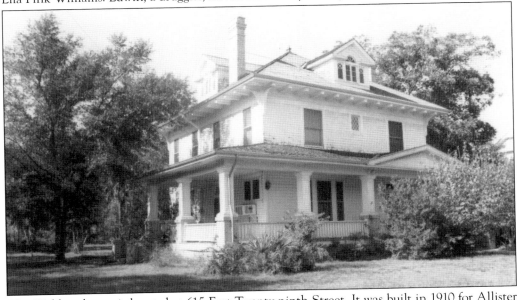

The Waldrop house is located at 615 East Twenty-ninth Street. It was built in 1910 for Allister and Nanne Waldrop. The family operated a retail business, and Nanne was a regent for the local Daughters of the American Revolution, twice the president of the Women's Club, and a president of the Bryan Civic Club.

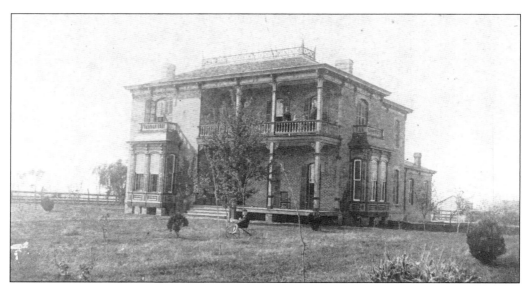

William R. Cavitt, a lawyer and banker, built Cavitt House between 1878 and 1880 as a wedding present for his bride, Mary Mitchell, niece of Harvey Mitchell. Behind the home was Cavitt's Pasture, which was almost used as a park by early Bryan residents. It had extensive flower gardens, a greenhouse, and a tennis court. Located at the corner of Haswell Drive and Thirtieth Street, it was the first grand house in Brazos County and has been listed in the National Register of Historic Places since 1976.

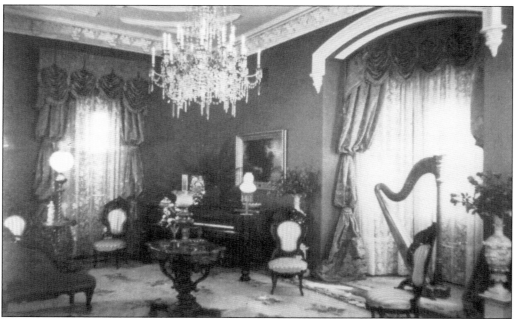

The interior of Cavitt House exhibited its Italianate style. Note the piano and harp. Most social events included a musical performance. In 1899, a Bryan musical club was formed. Their first performance took place at the home of Lila McInnis with the following musical numbers: a vocal solo by Florence McQueen, a vocal duet by Mrs. Sims and Delphia Adams, an instrumental solo by Mrs. Webb, and a sailor song by W. A. Witcher, H. C. Robinson, and Francis Marion Law Jr.

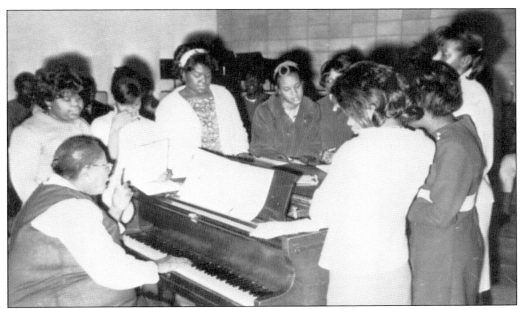

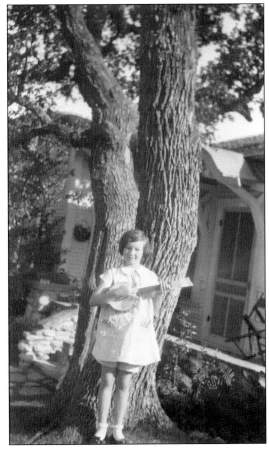

Johnnie Lightner Wyatt (at piano) directed the a cappella choir and taught music to several generations of Bryan youngsters. The students recognized her contribution by dedicating their Kemp High School yearbook to her in 1970. (Photograph from the *The Bruin* yearbook; courtesy of Diane Peterson Smith.)

Young and old alike appreciated many styles of music.

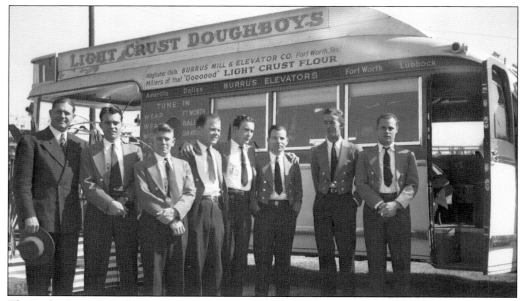

The Light Crust Doughboys were a Texas Western Swing band organized by the Burras Mill and Elevator Company. The band traveled the country in the 1930s performing and promoting the company's Light Crust Flour. They came to Bryan several times. In 1942, they played to packed stands at Bryan's Legion Fairgrounds.

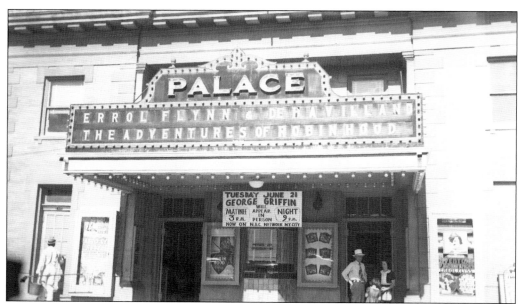

For decades, the Palace Theater provided Bryan audiences with a pleasing array of vaudeville shows and movies from its location on Main Street. In the 1980s, its roof suddenly collapsed (luckily no one was inside), and it has now been converted into an outdoor performance venue.

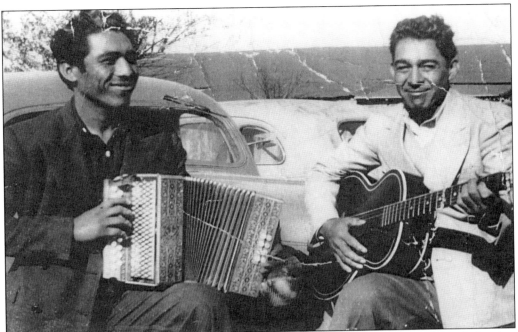

Sotero "Mr. Zuki" Guevara is shown playing the accordion, accompanied by an Estrada brother on the guitar. With a career spanning decades, Mr. Zuki played his accordion with gusto in many settings throughout the Brazos Valley, beginning in the 1940s.

Behind the bar and on the far right is Ambrosio "Bocho" Saenz. Bocho worked during the day and played his violin at night. In 1941, he formed his own band, the Les Bolero Kings. Their first booking was at the SPJST (Slovanska Podporujici Jednota Statu Texas, or Slavonic Benevolent Order of the State of Texas) Hall in Bryan. With an easy listening style of music, they played throughout the community. In 1964, Bocho opened the first of two businesses selling tamales.

As time marches on, so do young ladies' hairstyles.

Dominoes, especially "42," became popular in Texas, as card playing was frowned upon in some circles.

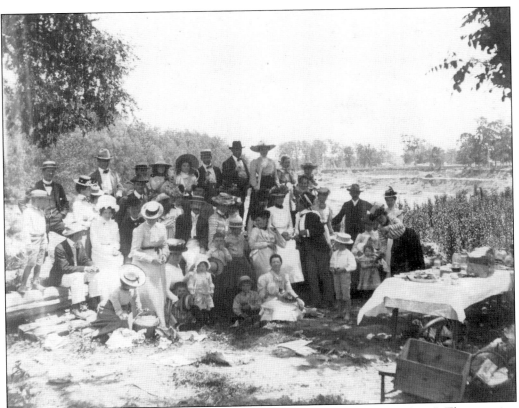

These elegantly attired people are picnicking along the Brazos River around 1917. The occasion was not recorded, but this was an elaborate undertaking. The Brazos River is 10 miles west of Bryan, and there is not a public park along the river anywhere near Bryan. These people likely brought the table with them for their picnic.

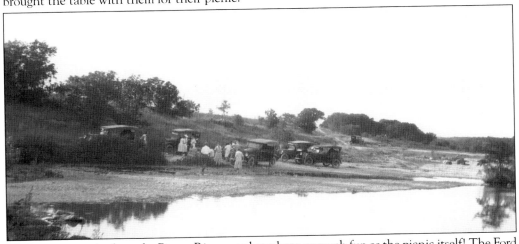

Getting to a picnic along the Brazos River may have been as much fun as the picnic itself! The Ford Model T was able to traverse more rugged terrain than many of today's automobiles. The Bryan–College Station area still sports serious Model T enthusiasts. It is the home of the Texas Touring Ts auto club, Texas Model T&A Parts, and Lilleker Antique Auto restoration specialists.

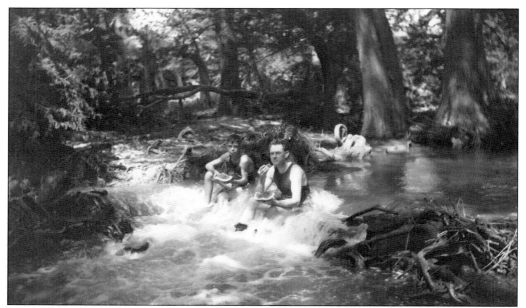

Local food preferences have ranged from simple to quite elaborate. Eating watermelon while sitting in the Navasota River certainly worked as a way to cool off in the summer during the 1930s. On the other hand, the *Daily Eagle* reported Mayor J. S. Mooring's family New Year's dinner at the Exchange Hotel in 1902 as including the following: oysters, apple fritters, oyster patties, corn, tomatoes, French peas, Irish potatoes, sweet potatoes, chicken salad, shrimp salad, celery, possum with sweet potatoes, turkey with cranberry sauce, roast beef, barbecued pig, boned ham, English plum pudding, mince pie, fruit cake, white loaf, banana cake, pineapple-and-walnut gelatin, tipsy squire, coffee, tea, and cheese balls.

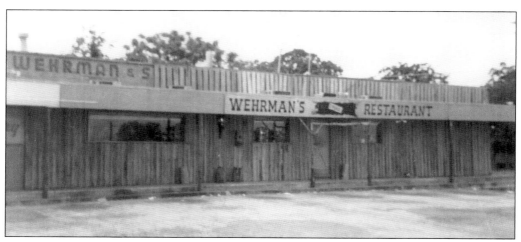

Wehrman's Restaurant was a popular family-style restaurant at 1009 West Twenty-fifth Street, now William J. Bryan Parkway. It was owned and operated by Herman Wehrman and his wife, Katie, known affectionately as "Aunt Kate." Although the Wehrmans were Czech, they were famous for their chicken-fried steak and french fries.

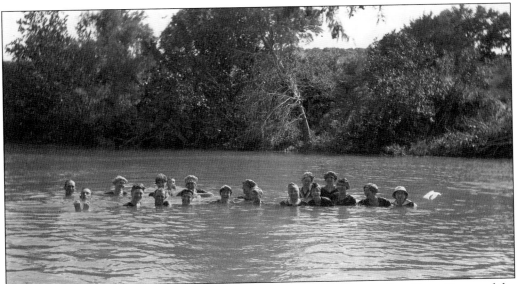

Swimming in the Brazos was a popular summertime activity. Society editor Dona Carter of the *Daily Eagle* reported one such gathering at the Sims plantation. The guests traveled from Bryan to the plantation for late-afternoon swimming, followed by a barbecue on the plantation grounds.

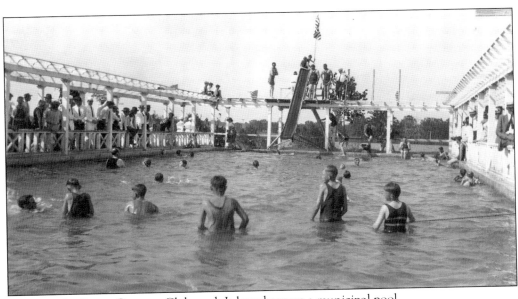

This was the Bryan Country Club pool. It later became a municipal pool.

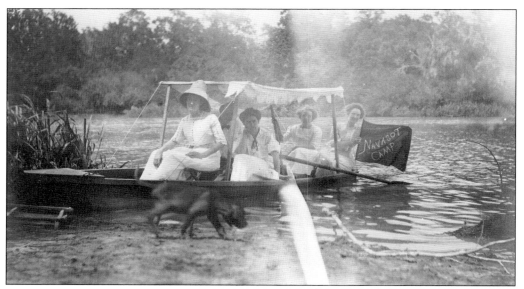

These young ladies were spending a day boating on the Navasota River, also known as "the Navasot."

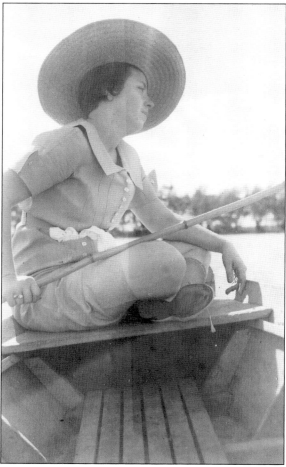

Lucile Dougherty is shown here fishing on Finfeather Lake, just south of Bryan, around 1935. She was a lifelong Bryan resident who worked for the city as a bookkeeper and accountant. She lived to the age of 95, and her carefully documented photograph collection has been donated to the Carnegie History Center.

The 26-acre Finfeather Lake was leased and stocked by the Bryan Fin and Feather Club in the early 1900s. Several thousand fish were put in the lake, a thousand of which were black bass from the government fish hatchery at San Marcos.

In 1939, the Bryan Country Club became the municipal playground. It included what is today the Travis B. Bryan Municipal Golf Course on Villa Maria Road. Here it looks like it is being used for a baseball game.

James Johnson and his wife, Ada, lived in Bryan's Candy Hill. In 1924, Johnson built a house with a tennis court for their recreation.

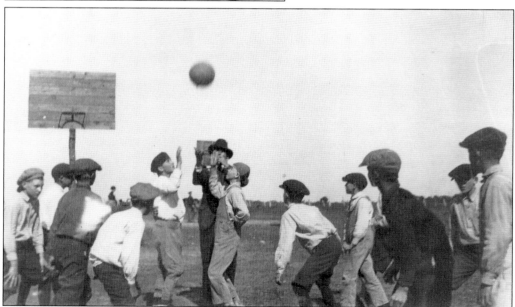

Basketball remains a popular pastime. In this 1924 photograph, schoolboys are enjoying the game on the playground at Edge School in northeast Brazos County. Beginning in 1920, A&M College's basketball team won the championship of the Southwest Conference for four consecutive years. Recently, the national rankings of the men's and women's teams from A&M have risen steadily. The area is also home to the Ag Silvers, a basketball team for women ages 60 and above.

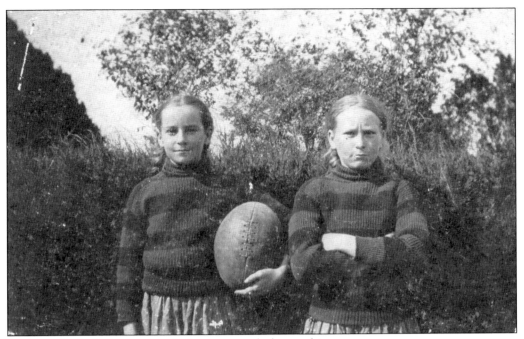

Rugby or football, these young ladies seem ready for anything.

The Villa Maria Academy encouraged its students to develop their athletic skills. The academy held an annual field day in May, with a basketball game, May pole dance, tennis, and a lawn party with ice cream, cake, and hot tamales. One of the most exciting girls' basketball games was during the 1915 field day, when the Red and Blue teams tied at 14 and had to go into overtime. The Reds finally won by a score of 16-14.

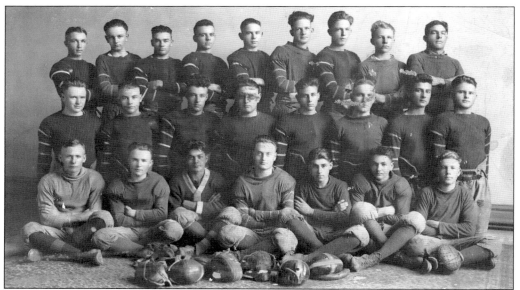

C. B. Hudson coached the Bryan High School football team that won the state championship in the first University Interscholastic League (UIL) game ever played in 1922. This 1919 Bryan High School team was a stepping-stone in winning that championship.

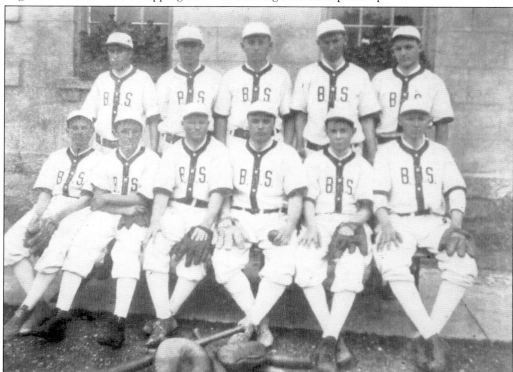

The Bryan High School baseball team is pictured here around 1920. This was the era of Babe Ruth, and baseball was America's sport. These boys would travel to Hearne and Calvert to play, while they dreamed of playing in New York City and Boston.

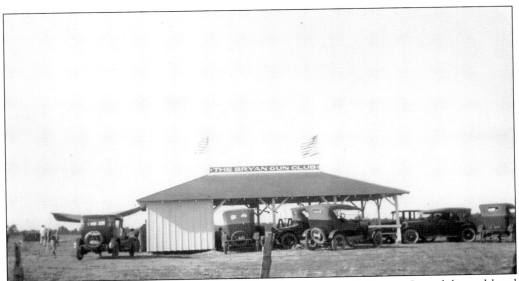

This is the Bryan Gun Club. Sport shooting was popular in early Bryan. Gun clubs and local fairs sponsored contests. On December 29, 1902, an enthusiastic trapshooting match was held between teams from Bryan and the Brazos Bottom involving 25 "blue rocks" per shooter. It resulted in a victory for Brazos Bottom. A winning score could usually be obtained by hitting 23 out of 25 targets. A "blue rock" was a clay target introduced by the Chamberlain Cartridge and Target Company in Cleveland, Ohio, in 1883. To meet the growing demand for the targets, Chamberlain set up a new factory in Findlay, Ohio, in 1901 to manufacture targets from a bluish clay that was strip-mined on-site. The factory in Findlay no longer operates; the property has been returned to a natural state and is operated by the Hancock Park District as the Blue Rock Nature Preserve.

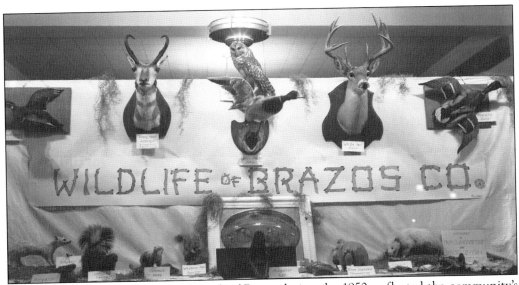

This exhibit in the First National Bank of Bryan during the 1950s reflected the community's interest in hunting and its local wildlife.

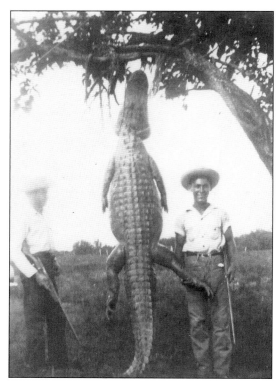

The American alligator was very common along the Brazos River. This specimen, shot in 1944, measured 10 feet, 3 inches. Alligators were depleted in the region to the extent that they were listed as an endangered species by 1967. Texas provided protection, and by 1987, the alligator was pronounced fully recovered and removed from the list of endangered species. Brazos Bend State Park is known for its alligator habitat.

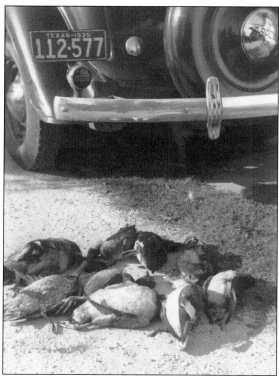

Duck hunting during the Depression of the 1930s was more than a sport; sometimes it was a necessity.

Four

SOME WHO HAVE CALLED BRYAN HOME

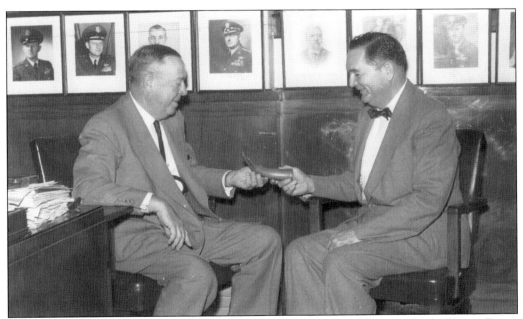

A hunting horn that had belonged to Moses Austin is examined by civic leader Travis Bryan (right) and J. T. Duncan of A&M College's history department. In 1820, Moses Austin had received permission to settle Anglo-American families in Spanish Texas, but died before establishing the settlement. His son Stephen F. Austin brought 300 families to Texas in the 1830s. Stephen F. Austin's nephew William Joel Bryan (his portrait is on the wall in the center of this photograph) granted the railroad a right-of-way through his acreage in Brazos County in 1865 and is the City of Bryan's namesake. Travis Bryan was a direct descendant. The portrait at far left is of Col. James A. Gunn, commander of the Bryan Air Base during World War II.

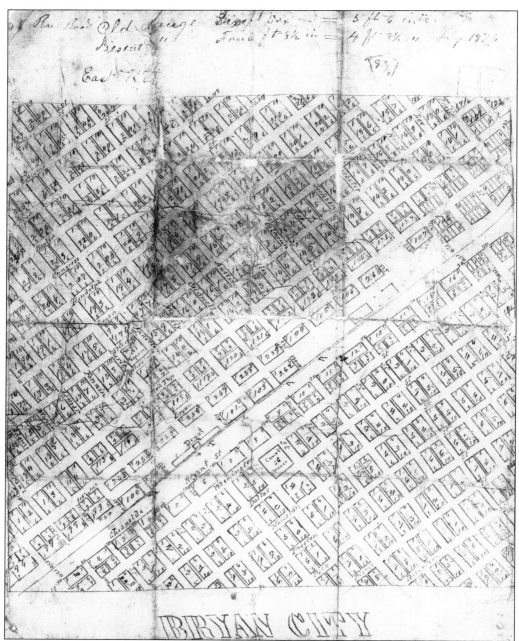

This July 1876 map is the oldest known plat of Bryan and was used by later city councils in the gradual planning and construction of the streets in the city. The first city limits were a mile square. Blocks were numbered and laid out along the railroad track that still runs north-south through the center of town. Main Street is the first street to the west of the original railroad track, and a public "square" extended several blocks in a north-south direction, located immediately to the east of the railroad. This was an exercise in city planning, as most of these streets and city blocks did not yet exist. This map was drawn by Harvey Mitchell and is preserved in the archives of the Carnegie History Center.

Known as the "Father of Brazos County," Harvey Mitchell was one of Bryan's first and most influential residents. He organized the first school and served as its first teacher. He built a courthouse that lasted for 20 years. According to the Texas State Historical Association's *Handbook of Texas*, he was also a justice of the peace, minister, hotel and store owner, surveyor, and blacksmith. Much of his life was spent in Boonville, the county seat before the railroad came to Bryan, but his work there laid the foundation for Bryan's development. The town of Harvey, approximately 6 miles southeast of Bryan, is named for him. His crowning achievement occurred in 1871, when he arranged for the new land-grant college in Texas to be located in Brazos County. Today this is Texas A&M University.

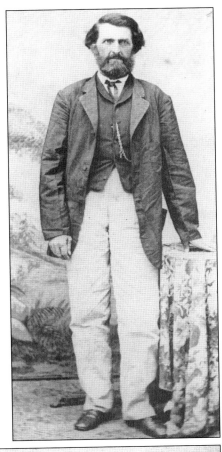

The Texas oil boom got its start with the discovery of the Spindletop Field near Beaumont in 1901. Bryan businessmen were quick to participate. In July 1903, Bryan investors, including T. P. Boyett, R. W. Howell, and W. O. Sanders, traveled to Sour Lake in Southeast Texas to arrange for drilling a well. While there, the men went to the Batson Gun Club. Several wooden derricks from the nearby field are visible in the background.

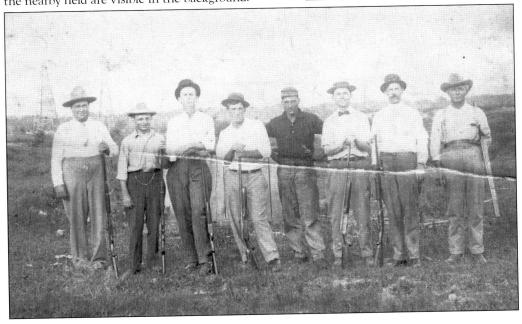

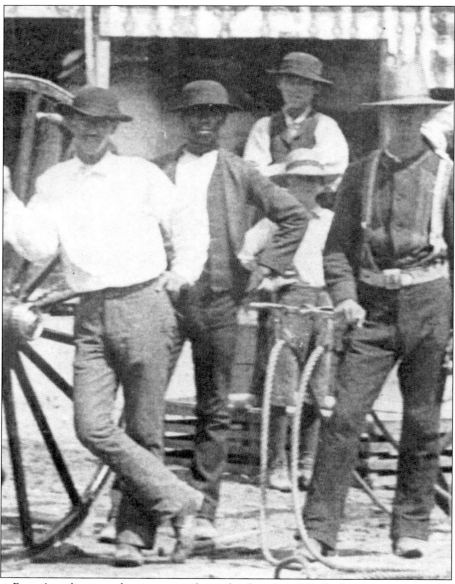

During Bryan's early years, the city council voted to hire Levi Neal, a black man, as a policeman with law enforcement authority over citizens of all races. From 1880 until 1900, Neal served the citizens of Bryan as a law enforcement officer. After 20 years of service, on February 24, 1900, ex-convict Dennis Calhoun shot and killed Neal on Main Street while Neal was arresting him. Neal was one of Texas's first African American peace officers to die in the line of duty. Members of the Bryan Police Department have searched in vain for a photograph to commemorate his sacrifice. This could possibly be a picture of him. It is from an 1887 image of one of Bryan's volunteer firefighting companies in which none of the men were identified (see page 13). In the center is a young black man who would have been about Neal's age. He dressed in the same style and stood with the same confidence as those around him, suggesting that he was an accepted member of the firefighting brigade. It is clear that Neal commanded an unusual amount of respect from Bryan citizens, which was remarkable during this period in the city's history.

Italian immigrants played a significant role in the expansion of the cotton industry in the Brazos Valley. These Sicilians came to the area in the late 19th and early 20th centuries. Landing first in New Orleans and working in the sugar cane plantations of Louisiana, they migrated to the Brazos Bottom and worked the cotton fields. By the early 1900s, Brazos County had one of the largest Italian populations in the country. They formed a largely self-contained community with a reputation for being trustworthy and hardworking. They proudly "took care of their own." Many began as sharecroppers "working on the halves" and purchased their own land in the Bottom as it became available. Early Italians in the area included John Lampo and Josephine Ruffino, shown in this photograph. The area around Mudville is still populated with a significant number of Italian descendants who continue to raise cotton and corn. Others have moved to town, and the names Lampo, Ruffino, Scarmardo, and Varisco are familiar to Bryan residents for their contributions to a variety of enterprises, including restaurants, real estate, meat markets, produce, groceries, and even crop dusting. Rosemary D. Boykin was a local author who wrote about the Italian experience in Brazos County.

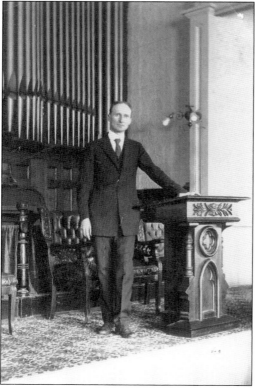

The Astins had a large plantation near Mumford in Robertson County, but after James H. Astin died in 1897, his widow, Onah Ward Astin, built this house in Bryan at 600 East Twenty-ninth Street. Onah Astin's son Roger Q. Astin took over the plantation, which remains under the ownership of the Astin family and is leased for growing cotton and corn by farming families living nearby.

The Reverend Dr. James Durham West was the minister of the First Presbyterian Church in Bryan in the late 1890s, when the congregation undertook a building campaign for a new sanctuary. The new building was completed but not paid for in 1906, and Dr. West had since moved to Mississippi. Finally, on March 29, 1914, the sanctuary was paid for in full, and the congregation held its official dedication by inviting the Reverend West back to Bryan to give the celebratory sermon.

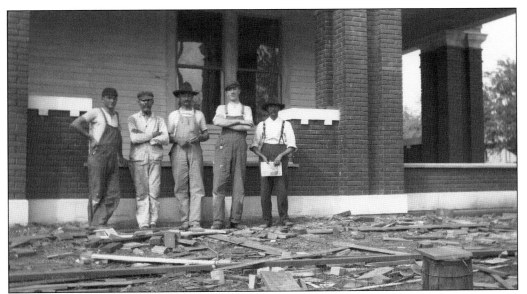

The names of these men in this c. 1905 photograph were not recorded, but they participated in Bryan's early building boom as carpenters and masons. It was because of their handiwork that the Texas Woman's College was almost completed.

Tyler Haswell (left) was Bryan's postmaster from May 5, 1898, until February 26, 1903. The Haswell family also owned a stationery and bookstore in Bryan. Notice Theodore Roosevelt's picture on the wall. In September 1901, Roosevelt became president of the United States.

These children, whose names
have not been recorded, were
residents of Bryan around 1910.

This *c.* 1890 map depicts an area
known as Freedmans Town, an
African American neighborhood
in northeast Bryan. To the east
was Candy Hill, another African
American neighborhood. Jeff P.
Mitchell, the county surveyor from
1886 to 1890, surveyed the map.

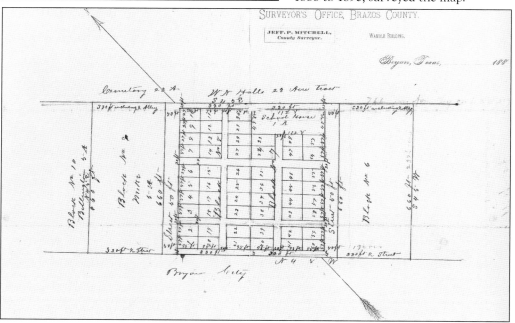

Many Bryan residents have shared an interest in horticulture, cultivated, perhaps, by the nearby Agricultural and Mechanical College of Texas.

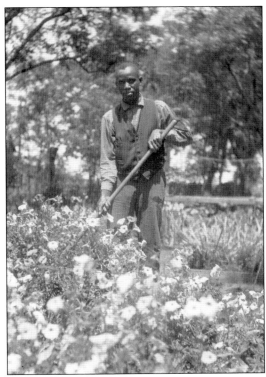

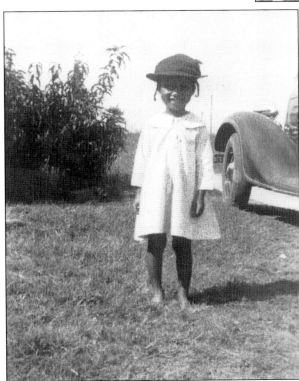

This little girl, named Mabel, was photographed at Finfeather Lake in 1935. Her mother's name was Ella.

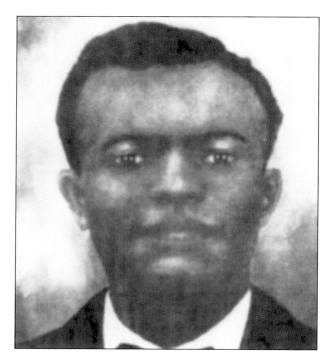

Shortly after graduation from Prairie View Normal School, Elijah Alonzo Kemp taught at the Colored Teachers Institute of Brazos County. Professor Kemp had a 20-year career as an educator, principal, superintendent, and school board representative for the Brazos County African American community during the early 20th century. His resourceful efforts to secure both a library and athletic uniforms for his students earned him iconic status that transcended racial barriers in Bryan Independent School District history long after his untimely death from fire in his home at 606 West Seventeenth Street in 1929.

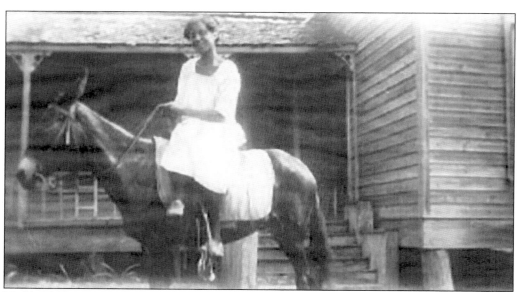

Haddie E. Dixon-Kemp was wife of E. A. Kemp and an educator and role model in her own right. After her husband's death, she moved to Colorado and then to Washington, D.C., where she worked for many years before returning to Bryan in 1965.

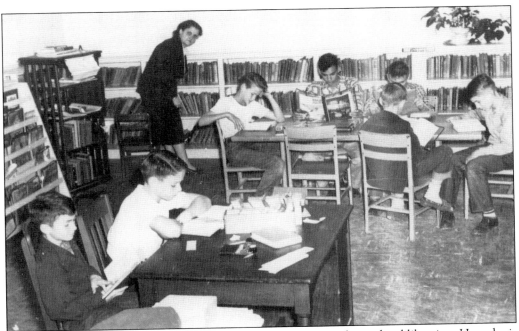

For decades, Dorothy Bunting was known to Bryan children as their school librarian. Here she is shown in the Lamar School library. Bunting also contributed to the section on Bryan's school history in *Brazos County History: Rich Past–Bright Future 1836–1986*, edited by Glenna Fourman Brundidge and published by the Family History Foundation in 1986. She also contributed to *Bryan Legends and Legacies*, edited by Betty Clements Foster and published by the City of Bryan in 1996.

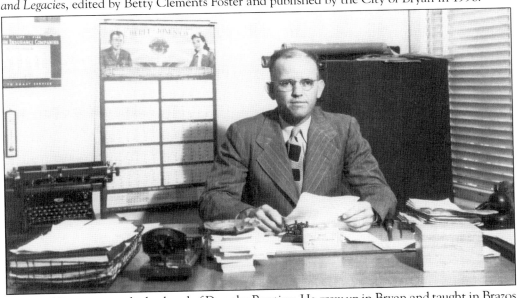

W. David Bunting was the husband of Dorothy Bunting. He grew up in Bryan and taught in Brazos County schools for 48 years. His fondness for his early years in Bryan are captured in "Dave's Place," the aforementioned essay by Dorothy Bunting in *Bryan Legends and Legacies*. Bunting and W. L. Hughes published a series of essays on the early history of College Station schools in A&M's newspaper, *The Battalion*, in July and August 1945.

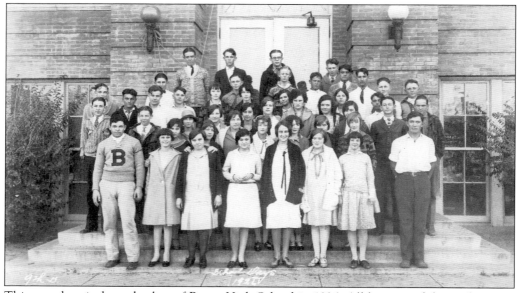

This was the ninth grade class of Bryan High School in 1926. All but one of the students are identified on the back of this photograph from the archives of the Dougherty Collection at the Carnegie History Center in Bryan. They are, from left to right, (first row) Charles Cummings, Dorothy McDowell, Lucile Dougherty, Kathleen Bullard, Janie Elliott, Helen Dowling, and Charles Moehlman; (second row) Hattie Bess Giffin, Winona McNeely, Beth Locke, Bessie Low Willey, Marie Graham, Pauline Morgan, and Bessie May Baker; (third row) Alvie Adams, Morris Kaplan, Mary Jane Dunn (in hat), Gussie Odem, Julia Bell Graham, Virginia Kurten, Joyce Smith, Evelyn Cahill, Illa Mae Hall, Frank Boriskie, and Fredrich Wright; (fourth row) Joe Butler, Nelson Ramsey, John Frank Wamble, Allen Withers, Gladys Bond, Bertha Mae Elliott, Ruby Robinson, Lida Dell Withers, and Steven Lobbella; (fifth row) unidentified, Lewis Wright, Jack Doone, Ralph Brogden, Richard Ramsey, James Palasota, Robert John Persons, and Jerimiah Merka; (sixth row) C. L. Eden, William Rawles, Milton Franklin, and Hugh Looney.

Pancho Valdez is pictured here in 1932. Valdez worked for D. Mike in the grocery business on North Main Street.

Ora Mae Echols is seen here on a recreational outing at Finfeather Lake in the 1930s. Echols appears to have served her country in the military during World War II. She married Don Dougherty, worked for the Department of Agriculture, and lived in Bryan for the remainder of her life.

Abram Robert Williams, known to his friends as "Shine," was listed in the Bryan City Directory as a porter living at 1001 North College Avenue in Bryan. College Avenue was later renamed Texas Avenue. Williams was employed by the B-L-D Agency (cotton buyers) for most of his adult life.

The names of these two men were not recorded, but they were involved in the drilling of an oil well south of Bryan, near Millican, in the 1930s. Oil and natural gas production did not contribute significantly to the local economy during the 1930s, but production has increased significantly since the mid-1970s.

John Konecny raised cattle on Leonard Road, near Thompson Creek, during the 1930s. At the time, this was rural Brazos County. Today it still has a rural flavor, although much of Leonard Road now falls within Bryan's city limits. A sewage treatment plant is planned to be built where Thompson Creek flows into the Brazos River.

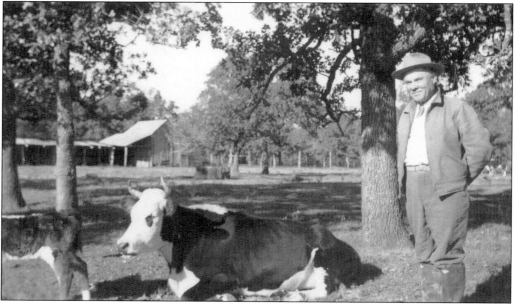

Howard Lee was an officer for the Bryan Police Department and was instrumental in designing their first uniform. This is Lee in the department's first uniform in 1933. He was, for a time, a motorcycle policeman. Officer Lee later became the city marshal for College Station. (Courtesy of the Bryan Police Department.)

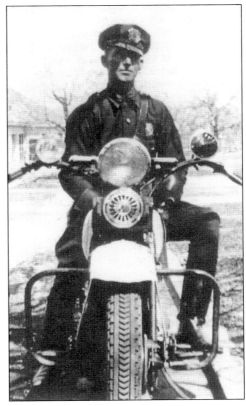

Fr. Timothy Jerome Valenta, pictured here in 1935, was ordained as a priest and appointed to St. Joseph's Parish in Bryan in 1933. He spent his life serving his parishioners in Bryan. Father Tim is remembered as a simple man of the people. He performed carpentry and plumbing repair work on the church and loved to go fishing. He was a humble and much loved member of the entire Bryan community. (Photograph from *St. Joseph Parish, Bryan, Texas: 100th Anniversary, 1873–1973*.)

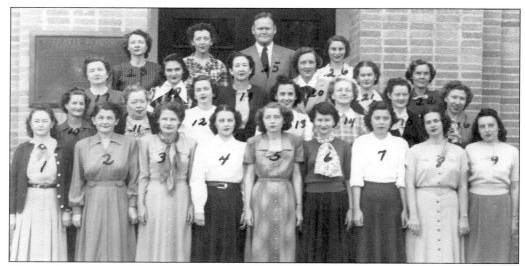

The teachers in this 1940s photograph of the Travis School faculty are, from left to right, (first row) Marybell McDonald, Orva Hyde, Elda Atkinson, Mae Holleman, Willie Mae Boyd, Lillie Mae Ford, Ruth Archer, Elaine Connelly, and Rosemary Smith; (second row) Mildred Cloud, Valeigh Kestler, Mary Frances Payne, Willie Clifford, Billie Jean Barron, Frankie West, and Marjorie Bryson; (third row) Lelia Beth Powell, Billye Gene Stricklin, Evelyn Bay, Ollie Little, Flo Miller, and Hazel Dooley; (fourth row) Gertrude Standby, Claribel Carrington, H. Wilson Cook, and Gail Fitch. Cloud spent her entire career teaching in the Bryan Schools, and a collection of her photographs is in the archives of the Carnegie History Center.

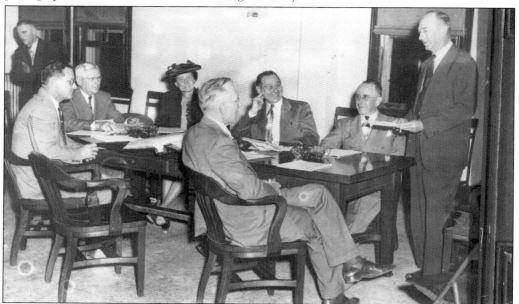

Members of the Bryan City Council are, from left to right, (standing) Charles Ramsey and Roy Vick; (seated) Noah Dansby, Mills Walker, Lucy Harrison, Roland Dansby, E. R. Bryant, and Ivan Langford (front). Former teacher Lucy Harrison was the first woman to serve on the city council. At this meeting in the late 1940s, the council debated over plans for the expansion of the electric utility.

During World War II, a military base, known as Bryan Field, was built in western Brazos County to train flight instructors for the U.S. Army Air Corps. This drawing from the *Daily Eagle* characterized the average army air corpsman stationed at Bryan Field. After the war, the field was decommissioned. Bryan lost out to Colorado Springs in a bid for the new U.S. Air Force Academy. The buildings that remain today are part of the Riverside Campus of Texas A&M University, housing parts of the Department of Nautical Archeology and various extension offices.

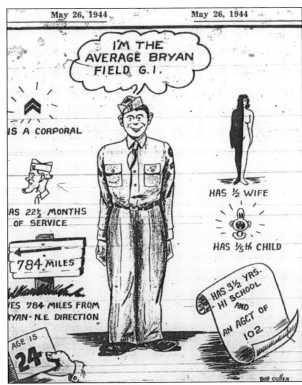

Bryan certainly loved its parades! Marching north up Main Street in this photograph are GIs from the Bryan Army Air Field.

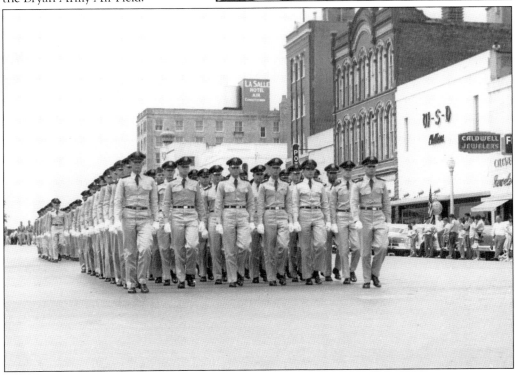

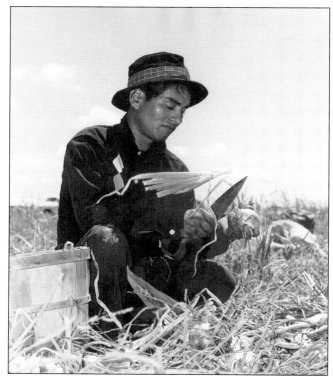

Brazos County's agricultural community has hosted a migrant labor population since after the Civil War. Some have settled permanently, but many return year after year to work in the fields. Conditions were harsh, but there also seems to be an easy camaraderie among the workers who appreciate the jobs and make this their way of living. Housing for the migrant workers can be a difficult issue. Labor houses are often situated near cotton gins.

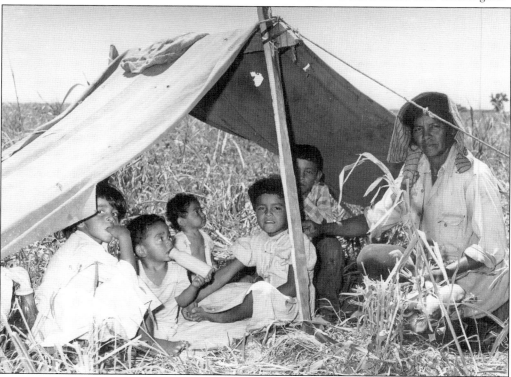

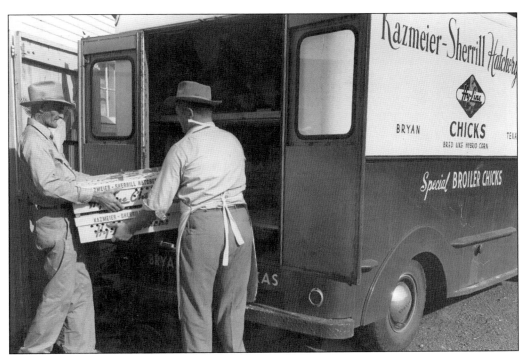

Poultry is part of Brazos County's agricultural industry. F. W. Kazmeier made friends among youngsters when he donated chicks for their Future Farmers of America (FFA) projects.

These boys gathering eggs in the 1950s are more evidence of the local poultry industry.

This SPJST Lodge was located near Wehrman's Restaurant in Bryan in the 1940s and 1950s. It served as a gathering place for a portion of the Czech community. A new lodge was built in Smetana in 1959 but was destroyed by a suspicious fire. Included in this 1940s photograph are members of the Hajek, Kucera, Patranella, Habarta, and Stasny families.

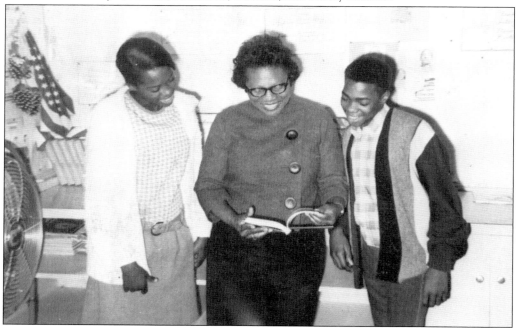

Olivia Banks (center) was a favorite English teacher and junior class sponsor at Kemp High School. (Photograph from *The Bruin* yearbook; courtesy of Diane Peterson Smith.)

Mel Pruitt was originally a Bryan health and physical education teacher and later served as the school counselor at Kemp and Neal Schools. She was instrumental in the founding of the Brazos Valley African American Museum. (Photograph from *The Bruin* yearbook; courtesy of Diane Peterson Smith.)

Kemp High School's yearbook staff of 1967–1968 are, from left to right, (seated) typist Janice Green, coeditor Melvin Jean Taylor, and editor Regenia Jackson; (standing) class editor Gabriel Harnsberry and faculty sponsor Rose M. Cowan. Marilyn Davis, Sherryl Shivers, and Alice Sims (not pictured) also served as typists. (Photograph from *The Bruin* yearbook; courtesy of Diane Peterson Smith.)

Board of Education

(Top insert) Mr. Calvin Guest, president of the Board. (Left to right, SEATED): Mr. Milton Turner, Mr. Johnny Lampo (vice president); Mrs. Mary Ritchey, and Dr. Carlton Lee. STANDING (Left to right): are Mr. Dick Holmgreen, secretary; Mr. Alton O. Bowen, superintendent; and Mr. Jesse Burditt

Serving on the Bryan Independent School Board of Education in the late 1960s were, from left to right, (inset) Calvin Guest (president); (first row) Milton Turner, Johnny Lampo (vice president), Mary Ritchey, and Dr. Carlton Lee; (second row) Dick Holmgreen (secretary), Alton O. Bowen (superintendent), and Jesse Burditt. (Photograph from *The Bruin* yearbook; courtesy of Diane Peterson Smith.)

This flag was a gift to the Bryan Fire Department from C. E. Oates, who was representing the Elks Club. Among those pictured here are Chief Herman Rice from the Bryan Central Fire Station, Mayor Ron Blatchley (Bryan's mayor from April 1983 to April 1985), George Dunn, Will Skopik (city manager), Jimmy Jones, Paul Maras, Weldon Watkins, Larry Mallett, Matt Lovell, and Raymond Janac (fire marshal).

Five

CONNECTIONS

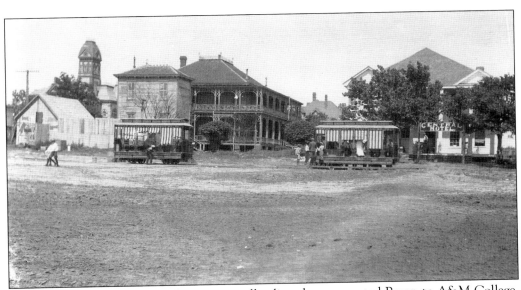

Beginning in 1910, the interurban was a trolley line that connected Bryan to A&M College, 4 miles to the southeast. Its reliability was often called into question, particularly in its early years when it was propelled along its tracks by an underpowered gasoline engine. When difficulties occurred (and they often did), the accepted cry was "ladies, keep your seats; profs, get out and walk; and cadets, get out and push!"

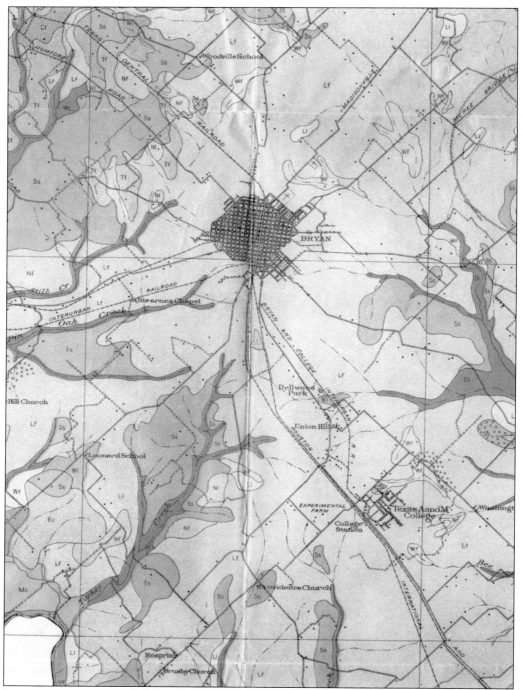

This 1916 map shows the interurban route, which connected Bryan to the college, 4 miles to the southeast, as well as the network of rail lines and roads that converged on Bryan. This map is an excerpt from a soils map of Brazos County published by the U.S. Bureau of Soils.

This is the view students had as they arrived at A&M College on the railroad. The tracks were 800 yards west of the main campus. In the distance are the double towers of Old Main, one of the first two buildings on campus. Old Main was destroyed by fire in 1912. To the left are tents that housed some of the cadets. Today these buildings have all been replaced, but the railroad remains, dividing the Main Campus from West Campus.

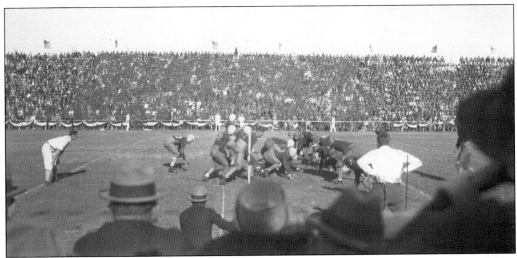

Aggies love their football and remain standing during games in Kyle Field in support of their team. This is the tradition of the Twelfth Man, which originated in January 1922 when Aggie student E. King Gill was called from the press box by Aggie coach Dana X. Bible to suit up in a uniform so he could enter the football game should the rapidly depleting ranks of the underdog Aggie football team need an additional player just to finish the game. By the end of the game, Gill was the only player left on the sideline, but he had stood proudly—ready to help his team. The tradition continues with the entire A&M student body standing during every game.

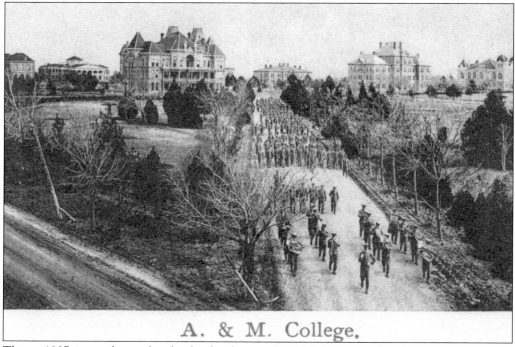

A. & M. College.

This *c.* 1907 image from a local calendar depicts the A&M's Corps of Cadets marching to the mess hall behind the Aggie band.

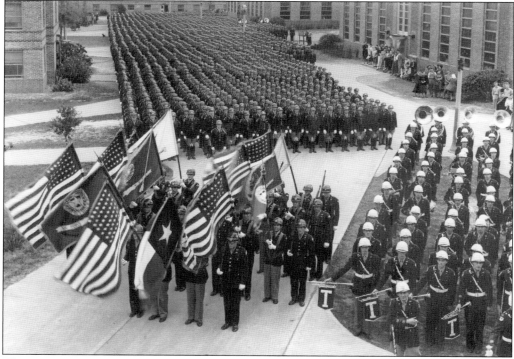

This 1950s image also depicts the Corps of Cadets behind the Aggie band.

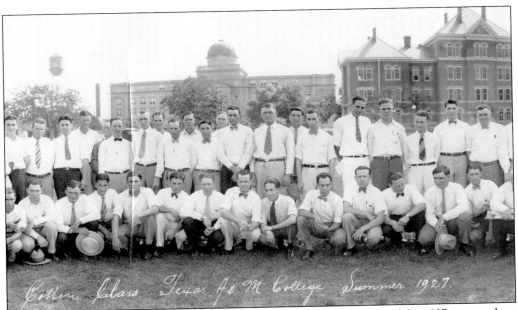

Cotton Class Texas A & M College Summer 1927.

A&M taught classes in grading and inspecting cotton. Here is a portion of the 1927 cotton class, which included Don Dougherty (standing third from left), who later was a key figure in the Bryan cotton industry because of his position as one of buyers at the B-L-D Agency.

These men were working on the railroad in rural Brazos County. The railroad was the vital link between Bryan and the Brazos Bottom and other parts of the state. The first rail line was constructed along the high ground between the Brazos and Navasota Rivers, from the southeast corner of the county to its northwest corner. This later became part of the Southern Pacific line that connected Houston and Dallas. The Hearne and Brazos Valley Railroad, known as the Peavine, ran to the west through the Brazos Bottom. Its construction began in 1878.

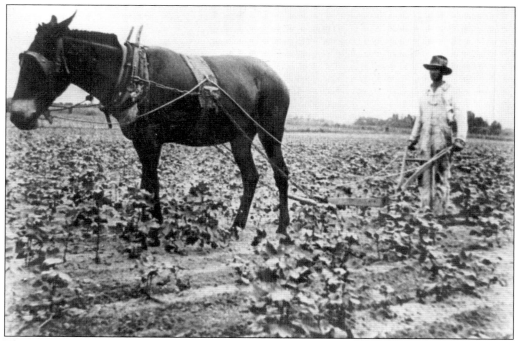

This man is plowing with a mule-drawn sweep stock between the rows of cotton to get the weeds out. Cotton was a labor-intensive crop that flourished in the rich soil of the Brazos floodplain and was the basis of the local economy until the arrival of the boll weevil in the early 1900s. After the abolition of slavery, cotton continued to be cultivated by tenant farmers in the Brazos Bottom. New techniques in the form of arsenic application were developed to discourage the boll weevils. This had serious unintended environmental consequences, particularly around Finfeather Lake where an agricultural chemical using arsenic was produced at the Elf Atochem plant.

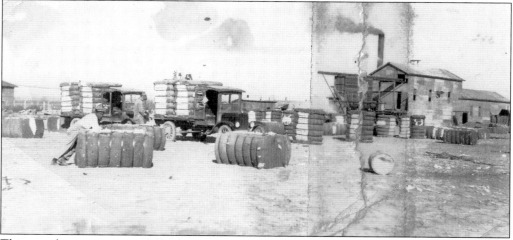

This was the cotton gin at Allenfarm in southern Brazos County. Most of the local plantations had their own cotton gins.

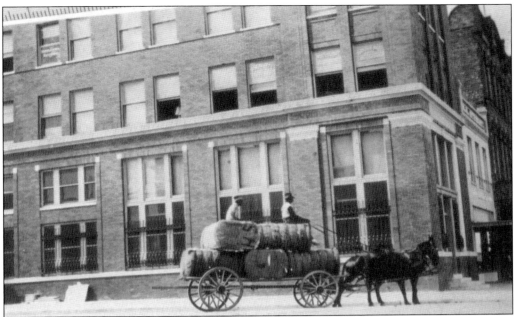

This wagon has come into town on Twenty-sixth Street and is turning left by the Astin Building to go to the cotton compress at the north end of town. Cotton growers ginned and baled their own cotton and then took their bales to the Bryan Compress, where their bales were literally compressed for shipment around the world.

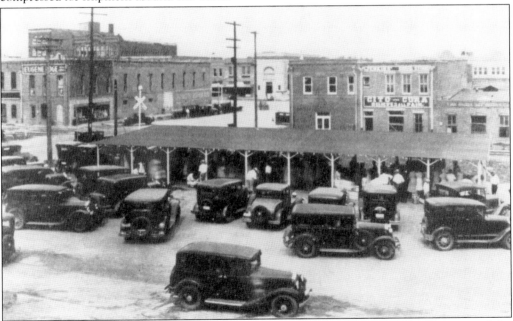

Around 1925, the original farmers' market in downtown Bryan attracted folks from around the county to buy and sell produce. The market was sandwiched between the railroad tracks and the Jenkins Drugstore. Edwin Jenkins operated his store at 203 North Main Street from 1893 until 1942.

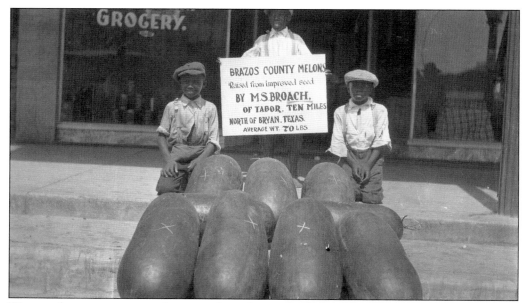

Watermelons were among the crops brought to the farmers' market. They are still grown in the area, particularly in Burleson County and around Hempstead, and remain a popular summertime treat.

In spite of Bryan's agricultural focus, there was interest in events elsewhere. The Century of Progress Exhibition in Chicago in 1933 attracted attention in the Bryan newspapers, and some residents traveled to Chicago to attend. A few lucky people from Bryan even reported taking a ride in the Goodyear blimp, as seen in this postcard.

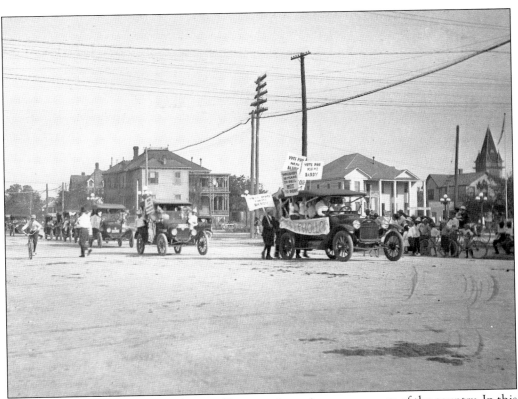

The issue of alcohol was a heated one in Bryan, as it was in so many parts of the country. In this Prohibition parade, the residents of the Steep Hollow community are making their views on the subject known as they march into town on Twenty-sixth Street.

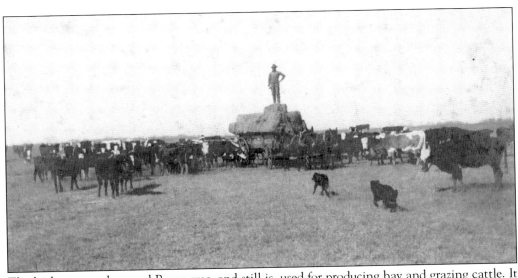

The higher ground around Bryan was, and still is, used for producing hay and grazing cattle. It is less fertile than the land in the Brazos Bottom.

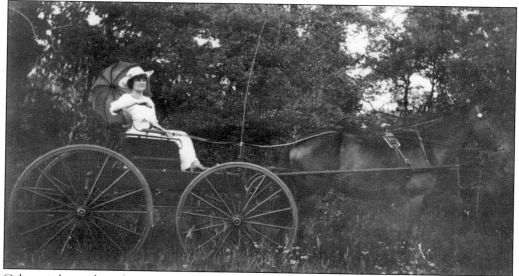

Calvert is located on the rail line in Robertson County, north of Bryan. It was the location of a thriving livestock auction that dealt in horses and mules. In this image, Ada Field of Calvert is posing with her fine horse and carriage.

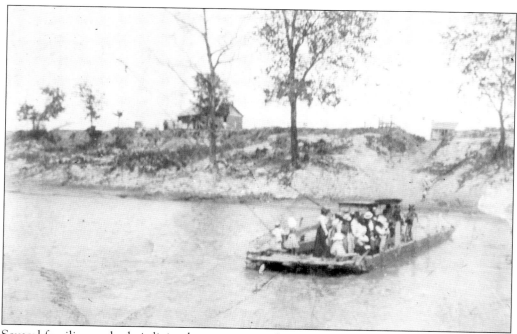

Several families made their living by maintaining ferry crossings on the Brazos River. In 1856, Dan Moseley established a ferry crossing at a site that was later crossed by the International and Great Northern Railroad. This location is near where Highway 21 crosses the Brazos today.

This bridge across the Navasota River linked Bryan residents to Grimes County to the east. This river is a braided stream through relatively dense vegetation along the eastern boundary of Brazos County. Its immediate floodplain has not been cleared for agricultural use.

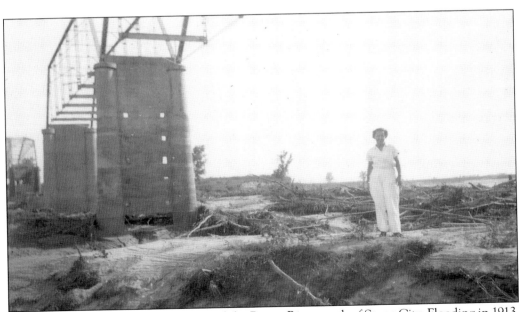

This was the old Pitts Bridge that crossed the Brazos River south of Stone City. Flooding in 1913, 1921, and 1926 ravaged this bridge, and it has not been replaced.

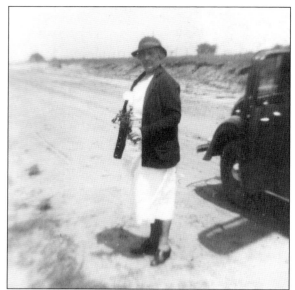

Highway 6 is an important landmark in Brazos County, linking Bryan with Houston to the southeast and Waco to the northwest. It roughly parallels the railroad, following the high ground between the Brazos and Navasota Rivers. Its construction during the 1930s was an event much heralded by Bryan residents, such as Woodie Mike, who was photographed alongside the new road in 1934.

Fig. 26. Participants in the dedication ceremony of the Texas Historical Marker placed at Steele's Store, October 11, 1992. Left to right: Dr. Charles Schultz, Chairman of the Brazos County Historical Commission and Archivist for the State of Texas; Mr. Don Angonia, long-time resident of Steele's Store; Mrs. Rosemary DePasquale Boykin; Daniel Ruiz, Charles Salvador, and Emilio Salazar, Knights of Columbus of the 4th Degree Color Guard, Bishop Gallagher Assembly; and The Honorable Carolyn Ruffino, Judicial Judge of the 361st District of the State of Texas. 1992. (Reproduced with the permission of Thomas H. Boykin.)

Steele Store is one of the two cotton-producing areas in Brazos County. Members of the Texas State Historical Commission, escorted by members of the Knights of Columbus in 1992, recognized its significance with the placement of this historical marker.

Six

BRAZOS FLOODING

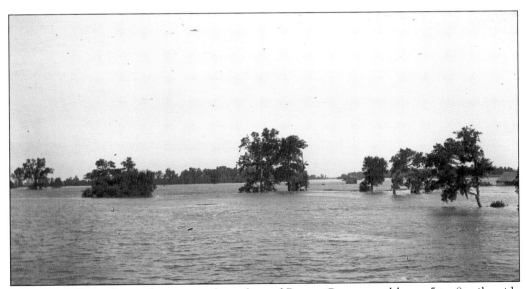

The Brazos River forms the western boundary of Brazos County and has a 5-to-8-mile-wide floodplain called the Brazos Bottom. On the northwest corner of the county, the floodplain falls between the Brazos and Little Brazos Rivers in an area known as Mudville. On the southern end of the county, the floodplain lies between the Brazos and Navasota Rivers in an area called Allenfarm. Between Mudville and Allenfarm, the Brazos floodplain lies west of the river in Burleson County. The fertile Brazos Bottom has been used for growing cotton since the mid-19th century. Major floods were recorded in 1856, 1899, 1913, and 1921, with smaller floods occurring every few years.

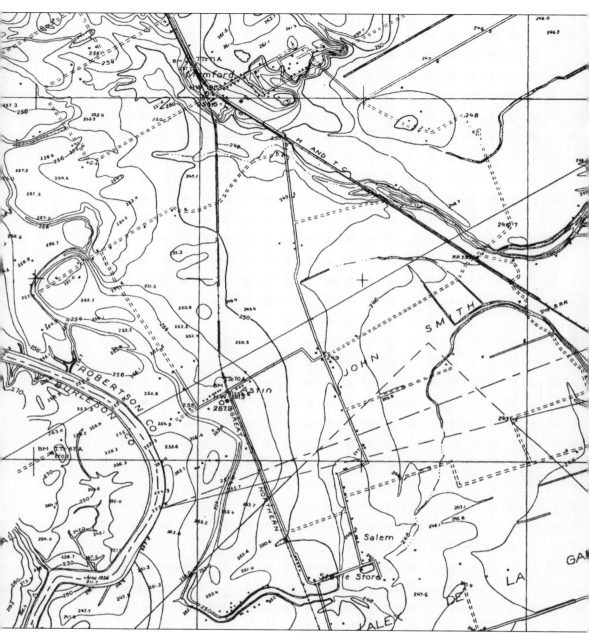

This map extends from the northern part of Mudville in Brazos County north to Mumford in Robertson County. The Brazos River meanders along the left side of the map. The two rail lines that leave Bryan traveling to the northwest clearly converge at Mumford. The contour interval is only 2 feet, so this area is extremely flat and barely above the normal level of the Brazos. The Astin Plantation is identified on the International and Great Northern Railroad line. Today Highway 50, between Mudville (Steele Store on this map) and Mumford, follows a slightly different course, but the rail lines remain unchanged. This map is from a 1926 U.S. Geological Survey Reclamation Map by B. F. Williams, titled "Texas: Brazos River Sheet 2." (Courtesy of the General Land Office of the State of Texas collection.)

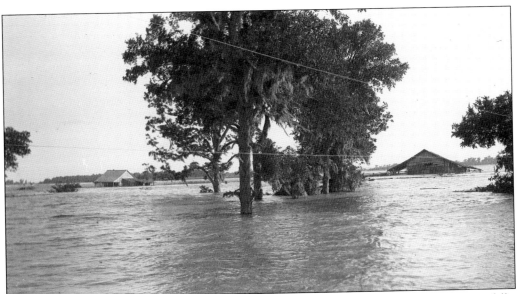

The labor houses of the tenant farmers, barns, and other outbuildings were in harms way as folks moved to the Bottomland to make their living by growing cotton. During the great flood of 1856, less material damage occurred than during later floods because the floodplain was not as heavily settled. Note the telephone lines in the foreground of this photograph. Telephone service was extended 13 miles northwest from Bryan to Mumford in Robertson County in 1887 and then down 6 miles to the Mudville area in Brazos County later that year.

When the river was not at flood stage, a row of labor houses such as this was a common sight in the Brazos Bottom.

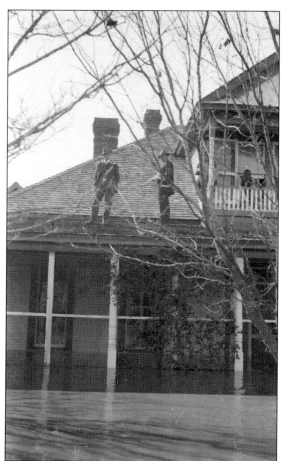

These men are surveying Brazos flooding from the roof of the Roger Q. Astin plantation house, located south of Mumford. This undated photograph may have been taken during the December 1913 flood. The lack of vegetation on the trees suggests a winter flood.

This was what the men in the previous picture saw as they surveyed the flooding from their roof. The painted picket fence is a sign of affluence. The group of buildings in the center includes the plantation's gin. To the left is a row of labor houses. The higher ground on the horizon is the slightly elevated International and Great Northern Railroad track. Brazos County is a half-mile to the right, and the Brazos River overflowed its banks a half-mile behind where the men were standing.

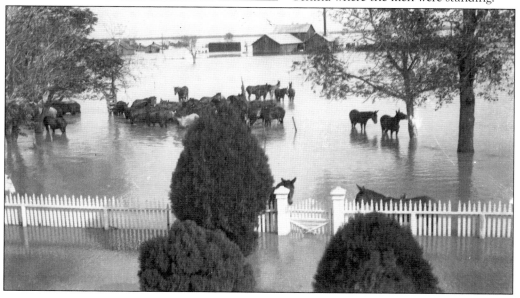

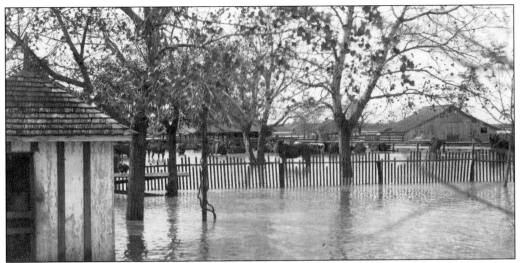

Flooding devastated cotton, thereby destroying the regional economy. The December 1913 flood was economically ravaging—even though it occurred after the harvest was complete—because it washed away the seeds for the next year's crop. Flood control was viewed as a necessity. Individual plantation owners constructed their own levees to divert water, but their efforts were ineffective.

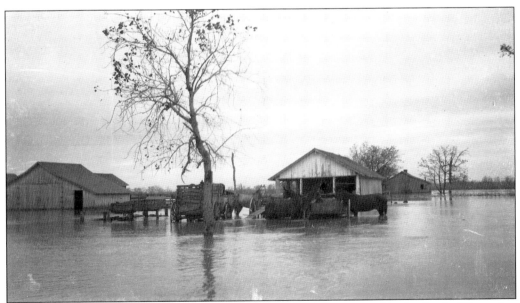

This plantation suffered from a winter overflow of the Brazos River, possibly the flood of December 1913. Behind the open garage is the side of a labor house, characterized by its brick fireplace. Bryan had at least two brick stamping facilities. Many small Texas towns had brick manufacturing facilities. To this day, it is not uncommon to find bricks stamped with the name of the Texas town where they were manufactured used for sidewalks and outdoor patios across the state.

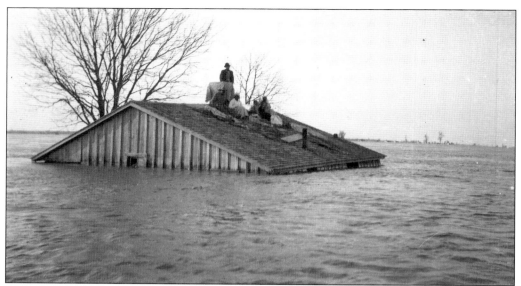

Many of the Brazos River landowners lived in Bryan because they considered the higher ground in Bryan to be healthier, but all of the laborers lived in the Bottomland. Flooding affected not only their livelihood, but also their homes and sometimes their lives. Having an ax in the attic was helpful, as people waited on a roof for the water to recede. This undated photograph of a winter flood may be from the December 1913 flood.

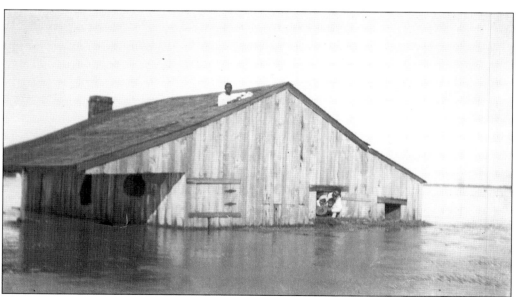

The typical labor house was constructed from wood with a brick fireplace for heating and cooking on an outside wall. Wooden doors, not panes of glass, were used for windows. Labor houses and outbuildings were not typically painted.

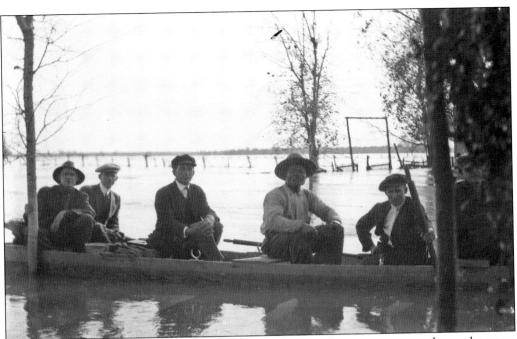

When flooding occurred along the Brazos River, Bryan residents were among those who came to the aid of stranded tenant farmers and their families. Many were taken by boat to cotton gins. During the 1913 flood, three Bryan residents, including Howard Cavitt and Henry Martin, died as a result of these rescue attempts. Howard Cavitt owned the Bryan Motor Company, and Henry Martin was the general manager of the International and Great Northern Railroad.

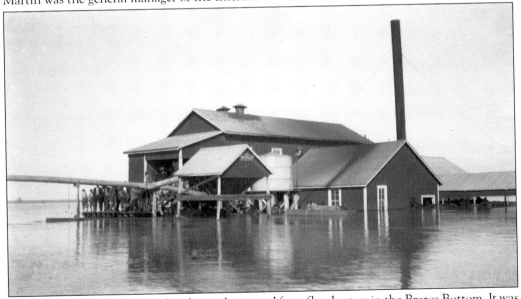

These cotton gins are crowded with people rescued from floodwaters in the Brazos Bottom. It was reported that during the December 1913 flood, 1,800 people took temporary refuge in 14 cotton gins. The gins were the largest buildings and were located on slightly higher ground along the railroad tracks. This is the J. S. Mooring gin, north of Steele's Store.

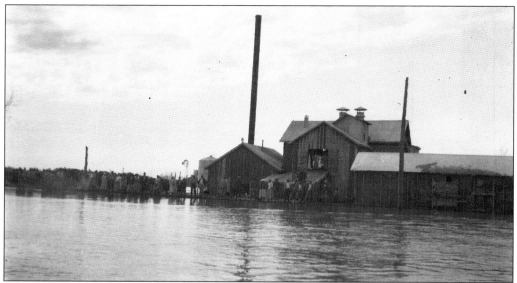

This is the Astin gin on the International and Great Northern Railroad line south of Mumford. Both this gin and the J. S. Mooring gin were clearly identified from an April 20, 1916, photograph in the *Daily Eagle* taken by Henry Locke, who was a bookkeeper for the A. M. Waldrop and Company store in Bryan.

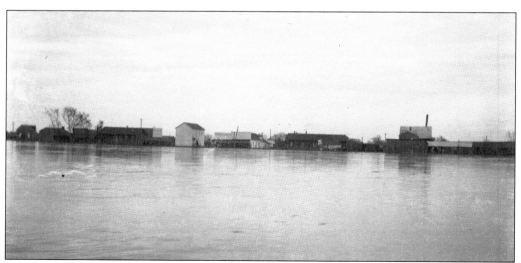

This was Mumford during a winter flood, possibly the flood of 1913. The buildings are clustered along the two rail lines that converged there. To the right was the gin, then a train depot, and the general merchandise house of Collier and Lovelace. The Edwin Wilson store was also in Mumford in 1916. These two stores each reportedly did $30,000 worth of business annually.

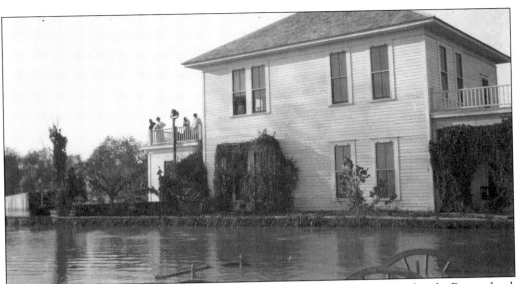

The home on the Milton W. Sims plantation on the west side of Steele Store Road in the Bottomland, between the Brazos and Little Brazos Rivers in northwest Brazos County, was also subject to flooding. From this balcony, Sims surveyed activity across his cotton plantation. This may have been the September 1921 or April 1926 flood. Note the bell by the balcony; the bell could be heard all across the plantation and was used to signal events related to plantation life. A sunroom was later added to the front of the home for health reasons, and the balcony on the right has been enclosed.

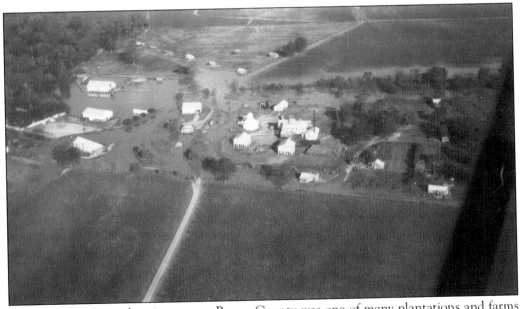

The Ward Mooring place in western Brazos County was one of many plantations and farms that suffered when the Brazos River overflowed. The large building near the center was the J. S. Mooring cotton gin. To the left of the gin is the old post office. The round building just above the post office is the seed house. There was a large pig barn, built by Tony J. Fazzino, just out of the photograph to the upper right. The seed house is the only one of these buildings still standing, although this site is still the headquarters of an agricultural operation.

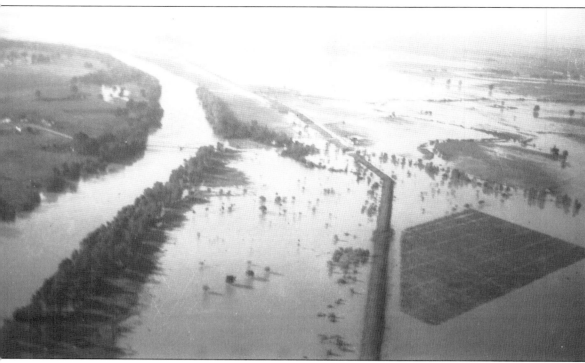

This is an aerial view looking to the south of the Brazos River flooding, probably in either 1921 or 1926. The main channel of the river is to the left of the photograph. Brazos County is on the high bank of the river to the extreme left, with the old Jones Bridge crossing the river into the flooded Brazos Bottom of Burleson County in the center of the image. The approaches to this bridge were washed out during the flood of September 1921, and its center support was rendered unusable by the flood of April 1926. Several years later, this bridge was replaced with the Highway 60 Bridge, located a quarter of a mile to the south. Jones Bridge is no longer standing, although two of its supports can still be seen in the river from the new bridge. This was in the heart of the local cotton industry where cotton was grown and where many of the laborers lived. In 1908, Texas law was challenged, leading to an amendment allowing counties to issue bonds for flood-control projects for the first time. Local landowners, including several prominent Bryan residents, successfully petitioned the Burleson County Commissioners to issue bonds authorizing the construction of a levee on the Burleson County side of the Brazos River in 1910. In the center of this photograph is part of the 27-mile-long levee constructed by laborers from a Memphis, Tennessee, construction company. The 1913 flood overtopped the levee, and almost 30 percent of its length was breached. A year later, it was repaired and raised by 3 feet. In 1921, this levee was again seriously breached. Other levees in the area were similarly ineffective. Construction of a dam across the Brazos River, creating Possum Kingdom Lake 200 miles upriver, in 1941 significantly reduced the frequent, massive flooding in the Brazos Bottom. Portions of the Burleson County levee, known as the Burleson County Improvement District No. 1, are still present along parts of the river. The trace of the old levee is shown on 1:24,000-scale U.S. Geological Survey topographic sheets, and there is a historical marker for the levee on Highway 50, approximately one mile south of Highway 21 in Burleson County.

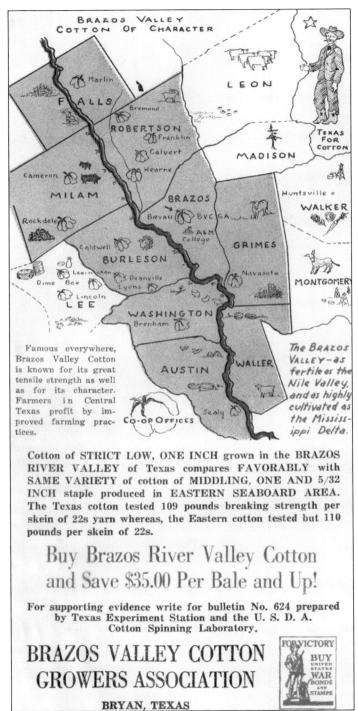

This advertisement from the March 1942 *Brazos Valley Cotton Grower* sums up nicely how Bryan is both literally and figuratively the market town at the center of a nine-county region economically tied to the cotton industry along this section of the Brazos River.